LEGENDARY ~~LOCALS~~

OF

THE LONG BEACH
PENINSULA

WASHINGTON

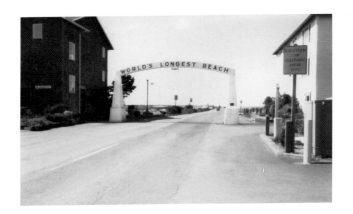

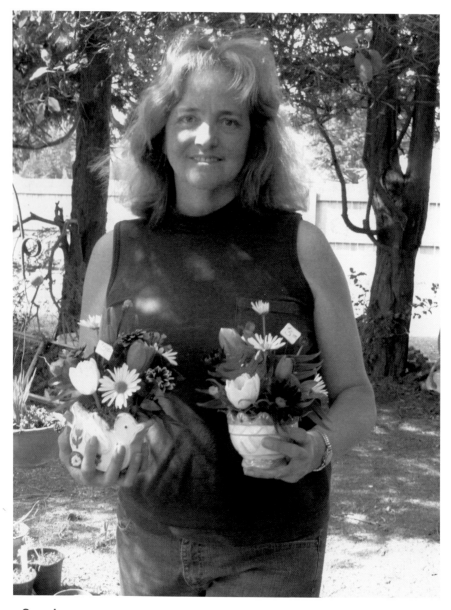

Sharon Saunders
Sharon Saunders is the "Flower Lady" whose blossoms beckon travelers whether they are arriving on or leaving the Peninsula. Her pay-on-your-honor flower stand at the east end of Chinook is an oblique reference to her struggle with myotonic muscular dystrophy—a reminder to stop and smell the roses. "Besides," Saunders says, "I feel good about myself when I'm working with flowers." (Cate Gable photograph.)

Long Beach Approach
The familiar slogan above the Long Beach Approach to the Pacific Ocean has been used to entice visitors since the last decades of the 19th century. (Sydney Stevens photograph.)

LEGENDARY LOCALS

OF

THE LONG BEACH PENINSULA

WASHINGTON

SYDNEY STEVENS

Pat —
Thanks for
supplying the
"key ingredient"
for Legendary Locals
Part II!

Sydney Stevens

LEGENDARY
LOCALS

Legendary Locals is an imprint of Arcadia Publishing
Charleston, South Carolina

Printed in the United States of America

Library of Congress Control Number: 2012948691

For all general information, please contact Arcadia Publishing:
Telephone 843-853-2070
Fax 843-853-0044
E-mail sales@arcadiapublishing.com
For customer service and orders:
Toll-Free 1-888-313-2665

Visit us on the Internet at www.arcadiapublishing.com

Dedication
To the many legendary locals, past and present, who have made the Long Beach Peninsula an exceptional and intriguing place to be

On the Cover: From left to right:
(TOP ROW) Jim Kemmer, oysterman (Courtesy of WBO, see page 61); Barbara Baker Poulshock, musician (Courtesy of Poulshock Collection, see page 93); Mark Dobney, US Coast Guard (Courtesy of CPHM, see page 35); Betty Paxton, nonagenarian employee (Sydney Stevens photograph, see page 102); Helen Thompson Heckes, educator (Courtesy of EFC, see page 60).
(MIDDLE ROW) Susan Holway, Finn Fest organizer (Courtesy of Holway Collection, see page 58); S.A. Matthews, builder (Courtesy of CPHM, see page 87); Chief George Allen Charley, Chinook leader (Courtesy of CPHM, see page 14); Sharon Saunders, "Flower Lady" (Cate Gable photograph, see page 2); Noel Thomas, artist (Courtesy of Open House Collection, see page 123).
(BOTTOM ROW) Val Campiche, bookstore owner (Courtesy of Campiche Family Collection, see page 110); Luke Jensen, fisherman (David Jensen photograph, see page 38); Willard Espy, writer (Courtesy of EFC, see page 54); Jayne Bailey, café owner (Sydney Stevens photograph, see page 77); Martha Turner Murfin, children's advocate (Courtesy of EFC, see page 27).

CONTENTS

Acknowledgments 6

Introduction 7

CHAPTER ONE Along the Banks of the Columbia 9

CHAPTER TWO On the Shores of Willapa Bay 39

CHAPTER THREE Among the Dunes of the Pacific 81

Bibliography 125

Index 126

ACKNOWLEDGMENTS

This book is a collaborative effort that could not have happened without the generosity of the families and friends of past and present legendary locals, and the amazing cooperation of the Long Beach Peninsula community. Mostly, though, I must thank those legendary locals of current times, many of whom protested loudly that they did not consider themselves legendary in any way. Not so! They have each made a difference to this fragile, isolated corner of southwestern Washington. They have paved the way and set the example and gone the extra mile. They are legendary, indeed!

Special thanks also go to the Columbia Pacific Heritage Museum for opening its archives to my research efforts, and to collections manager Barbara Minard for her careful guidance and hours of technical support. She should have had her own page in this book, but she adamantly refused.

Also, I wish to thank Keith Cox for the use of photographs from his *Willapa Bay Oysters* documentary project, as well as from his personal family files. And, in addition to opening their personal photographic collections to me, Dobby Wiegardt (see page 69), Tucker Wachsmuth (see page 50), and Gordon Schoewe (see page 111) all provided invaluable tidbits of information. Extraordinary thanks, too, to neighbor, friend, and cartographer Paul Staub for making a map of the Long Beach Peninsula that is perfect for this book.

I also want to acknowledge the many, many legendary locals that I could not squeeze within these covers. So many people, past and present, came to mind or were suggested to me that I cannot help but think a part two might be appropriate at some future date.

Unless otherwise noted, the images in this volume appear courtesy of the Columbia Pacific Heritage Museum (CPHM). Some contributors are abbreviated as follows: Dobby Wiegardt Collection (DWC), Espy Family Collection (EFC), Holway Family Collection (HFC), Pacific County Historical Society (PCHS), Wachsmuth Family Collection (WFC), and *Willapa Bay Oysters* (WBO).

INTRODUCTION

The tiny finger of land in the southwesternmost corner of Washington State is popularly known as the "Long Beach Peninsula." Officially, however, it is still the North Beach Peninsula, so named because it stretches northward from the mouth of the Columbia River as opposed to the Oregon beaches to the south. By whatever name, it is an area that gives rise to rugged individualists, independent thinkers, creative dreamers, and innovative problem solvers.

According to their legends, Chinookan-language speakers have inhabited the Peninsula "from the beginning." Theirs was a culture based on salmon and cedar, both plentiful in the area. The Chinooks' expertise as traders was exceeded only by their acumen as boatmen, and these skills, in combination with their centralized location, made them important middlemen in the trade-based economy of northwestern tribes.

It was also interest in trade—the fur trade and trade routes to the East—that brought the first Euro-American explorers to the area and, eventually, led to settlement by whites. Early pioneers and Donation Land Claim applicants were after the abundant natural resources of the region. Timber, oysters, and salmon each played a role in the development of the Peninsula settlements in the mid- to late 1800s.

The area was isolated, accessible only by water. So thickly grew the trees and underbrush that more than a generation passed before any serious attempt was made at overland transportation routes, though the 28-mile peninsula averaged less than two miles wide.

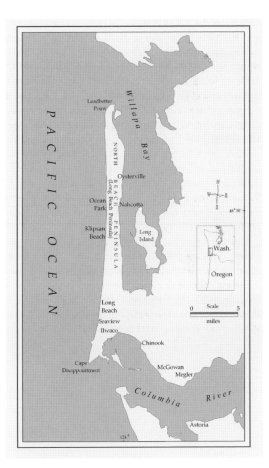

Long Beach Peninsula Map
The Long Beach Peninsula is essentially a 28-mile-long sandspit. It has built up over the last 10,000 years from the sands continuously washed down the Columbia River and pushed northward during winter storms. (Paul Staub map.)

As early Oysterville resident John Marshall wrote to his wife in New York, "I go in the woods and look for trees suitable for house but can't find them they are so bige [sic]. They are from 150 feet to 200 feet high and from 3 feet through to 6 feet and it is so much labor to get them they stand so close together that we can't hardly get through them. I never saw such woods until I came to this country. Here we can't see anything else."

When transportation magnate Lewis Loomis (see page 49) completed his narrow-gauge railroad from Baker Bay on the Columbia to a terminus four miles south of Oysterville in 1889, the interior of the peninsula finally became approachable. In response to a concerted public relations campaign by the railroad, the first summer visitors soon arrived, and cottages and vacation cabins were built in increasing numbers. The population has grown slowly but steadily ever since.

It was the railroad, too, that blurred the line between the actual geographic peninsula and the rest of the mainland. When the 13-mile rail extension from Ilwaco to Megler was completed, the entire length of the line began to be thought of as part of the Long Beach Peninsula. These days, no one questions that "the Peninsula" encompasses all the communities from Chinook to the peninsula's northernmost tip; this understanding is further reinforced by the inclusive jurisdiction of the local school and hospital districts.

From earliest times, the expression "when the tide's out, the table's set" has served as a defining mind set of the Peninsula's residents. In the boom-or-bust economy of the pioneer days, a run of stormy weather or an unexpected environmental catastrophe could mean disaster for families dependent upon the area's natural resources for their living. But with clams, crab, fish, or oysters always available to the industrious, no one needed to go hungry.

Later, during the Great Depression, families moved to the Peninsula because it was an area where a "subsistence living" was readily available. The bounty of forest and sea could easily be supplemented by vegetable garden and orchard. More recently, the Peninsula has become a mecca for low-cost vacations and is a viable retirement option for those on fixed incomes. According to the recent censuses, the median income of Pacific County ranks well below that of most other Washington counties, and nearly a third of Peninsula residents are senior citizens.

The Peninsula's principal livelihoods—oystering, fishing, farming, and tourism—have remained the same since the first permanent white settlers arrived 160 years ago. Leaders in those endeavors guard against industrial development and are diligent with regard to zoning standards. They are often opposed by those whose interests favor population growth and who complain that, without available jobs, the area will stagnate.

Just as it is a refuge for those who want to retreat from the hubbub of the mainstream, the Peninsula is also a haven for artists and writers and those seeking an alternative lifestyle. From Joe Knowles (see page 121), Maine's "Nature Man" of the 1930s, to Trevor Kincaid (see page 56), the award-winning zoologist from the University of Washington, the Peninsula is known for providing a life of intellectual and creative support.

People who live at "the beach," as they call the Long Beach Peninsula, laughingly refer to it as "the end of the known world" or the "dropping off place." They treasure its isolation even as they curse its lack of amenities. And, while the residents welcome the tens of thousands of visitors who descend during vacation periods, the sigh of relief is almost audible when tourist season is over and life settles once more into a feeling of comfortable obscurity.

CHAPTER ONE

Along the Banks of the Columbia

Just as the Columbia River gave rise to the 28-mile sandspit that is the Long Beach Peninsula, it was the river that became the first focal point of human endeavor and habitation in the area. Chinookan-speaking people plied the river's waters and depended upon its salmon runs. Explorers from Asia and Europe speculated about the river's existence and, finally, "discovered" it, giving it the name we now know it by. Lewis and Clark trekked across the continent to find its mouth, and early Euro-Americans began the area's first permanent settlements along its banks.

Always, the river has served as the main thoroughfare, and always, its salmon bounty has provided the economic base for those who live nearby. Early settlements on the northern shore included Middle Village, Pacific City, Chinookville, and McGowan. Nowadays, there remain two communities that are considered part of the Long Beach Peninsula—Chinook and Ilwaco, both settled in the last half of the 19th century. Also important to the area are Fort Columbia, Cape Disappointment State Park at the site of old Fort Canby, and the Cape Disappointment Coast Guard Station. Livelihoods of the riverside inhabitants continue to center on fishing, fishing-related occupations, and water transport.

Many are the stories of sailors and fishermen who braved the waters of the Columbia and crossed its dangerous bar in an area so treacherous it is still called "the graveyard of the Pacific." There have been "salmon wars" over fishing methods—pound nets (also called fish traps) versus gill nets—and there have been lengthy legal battles over fishing rights and dredging operations. The people who live along the north bank of the Columbia are known for their strong opinions, their strong work ethic, and their strong family and ethnic ties. Among them are countless legendary locals.

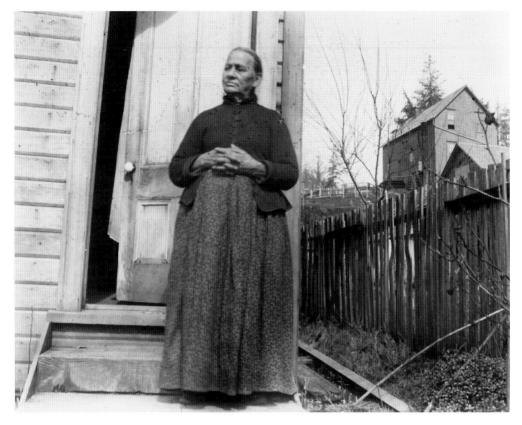

Amelia Aubichon Petit

Called "Grandmère" by her many grandchildren and great-grandchildren, Amelia Aubichon Petit settled in Chinookville in 1866 with her husband, Amable, and the first seven of their ten children. They arrived from upriver on the Columbia in a two-masted schooner, which none of those onboard knew how to sail against the wind. Consequently, they were able to move only with the outgoing tide or when the wind favored them. Much of the time they were anchored or tied up to the bank waiting for the tide to turn. It took over a month to make the hundred-mile trip from Portland to Chinookville. Amelia was the granddaughter of Chief Comcomly, principal chief of the Chinook Confederacy and described by Washington Irving in his book *Astoria* as "a shrewd old savage with but one eye." Her parents were MaryAnne and Alexis Aubichon, who were in California building a grist mill when Amelia was born in 1830. Amelia Petit had many interesting experiences during her long life. She remembered watching Mount St. Helens "burst" in the mid-1840s; she knew Dr. John McLoughlin, factor of the Hudson's Bay Company; and she knew a young man named Ulysses S. Grant, who would go on to become a Civil War general and, later, president of the United States. She remembered when a bob-tailed pony and a range of mountains shared a common name: "Skuse." (The pony is now called Cayuse and the mountains are the Siskiyous.) She also remembered the beginning of the wheat-raising industry in Oregon Territory when the sacked grain from French Prairie was brought down the Willamette River in bateaux operated by Indians, and how it eventually was taken to ships waiting at a place called "Boatland" by the whites but was pronounced "Portland" by the Indians. The name for the new city was chosen by the flip of a coin. In later years, as Chinookville began to wash away into the river, the Petits moved downstream to Ilwaco. Their great-granddaughters, the Herrold twins, recalled that Grandmère was "very tiny, very old, smoked a clay pipe filled with *kinnikinnick* (Indian tobacco or bear-berry), and spoke French. They recounted that her house was spotlessly clean, and she scrubbed her floors with beach sand. "When Grandmère Petit died," they said, "the Indians all came from Bay Center and sat cross-legged facing the Presbyterian Church during her funeral."

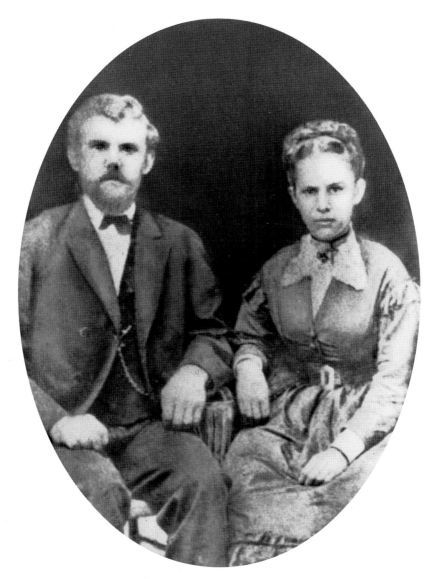

Frederick and Catherine Petit Colbert

Frederick and Catherine Petit Colbert lived first in Chinookville, east of present-day Chinook, near the site of Lewis and Clark's 1804 Station Camp. There, in 1872, they built a house and a store. As their oldest children approached school age, however, Catherine insisted that they move downriver a few miles to be closer to the new public school. In Ilwaco, Fred went into the burgeoning fish trap business and constructed a sturdy house from the boards of their Chinookville buildings. As their family continued to grow, they built an addition to the south end of the house and, later, another larger addition to the north. The upstairs portion of this last addition served as a dormitory for Fred's fishing crews by night and was called "the knitting room" by day, when it was used by family members for making and mending nets and knitting web for fish traps. As those additions were made to the original house, Fred insisted that the east-side walls be placed in a long, straight line, north to south. He had sailed before the mast as a boy and still loved all things connected to the sea. To him, the long wall resembled the side of the ships he had sailed upon when he left his native Sweden. The house, which is now listed in the National Register of Historic Places, was gifted to the Washington State Parks Department by the Colbert family in 1990.

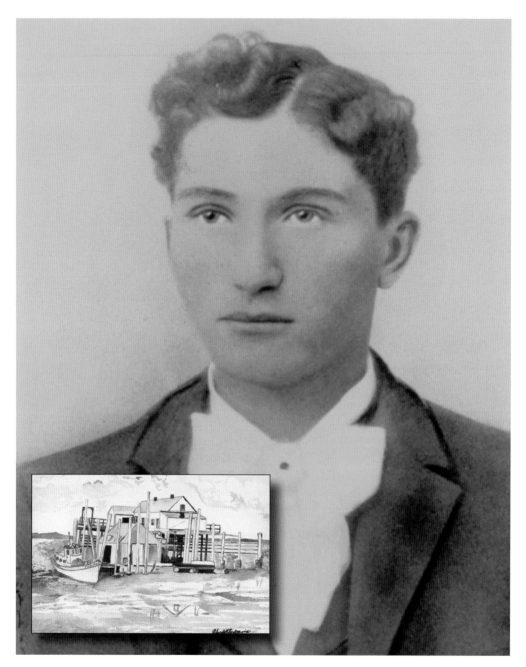

Roy Hudson Herrold

Roy Hudson Herrold arrived in Ilwaco in 1890. He operated fish traps until they sanded in after construction of the north and south jetties at the mouth of the Columbia. He then bought into the Tokeland Oyster Company and managed its station east of Nahcotta (inset)—one of seven such stations built on piling and standing over the open waters of Willapa Bay. There, oysters were culled, graded, and readied for shipment. Although some Japanese families lived at the stations year-round, the Herrold family continued to live in Ilwaco, and Roy went home when he could. When school was out each June, his wife and six children joined him at the station for the summer. (Inset, Charlotte Herrold Davis drawing.)

The Herrold Twins

Identical twins Charlotte Herrold Davis (the elder by 24 minutes) and Catherine Herrold Troeh were born in Ilwaco in 1911. They attended Peninsula public schools and were graduates of St. Vincent's School of Nursing in Portland, Oregon. Charlotte, with her husband, Edgar, wrote *They Remembered*, a four-volume book series about the family heritage of Peninsula residents. Catherine was an artist, historian, activist, and advocate for Native American rights and culture. Both were elders of the Chinook tribe and direct descendants of Chinook chief Comcomly. Of their childhood, they said, "Our Indian heritage was seldom talked about. In those days, it was not something to be proud of. When Ilwaco was settled, most of the Indians were run out. Grandmère Petit (see page 10) was one of the few who stayed. We always felt we were different from our friends."

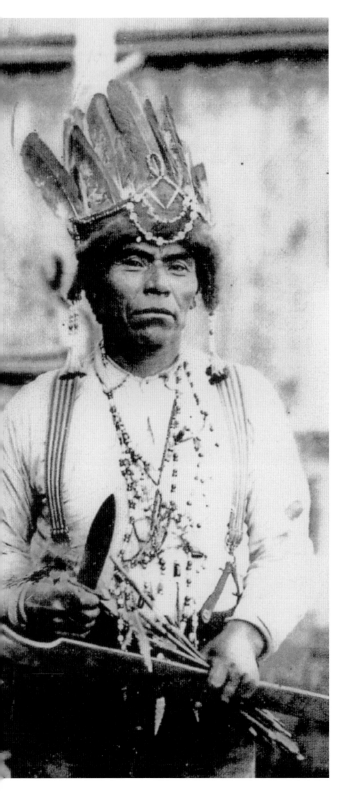

Chief George Allen Charley
George Charley was a familiar figure on the Long Beach Peninsula, particularly to the fishermen of the area. Each year during the first decades of the 20th century, he led his Chinook Indian crews to traditional seining grounds on the Lower Columbia to fish for salmon. Harland Plumb, of Chinook, was eight years old in 1920 when his father made a deal with Chief Charley to seine along the beaches of Peacock Spit and Sand Island, two of the most productive seining areas on the Lower Columbia. Later, Plumb wrote, "My father and the other whites shared in the catch only because they furnished the gear and part of the labor. But Chief Charley and his tribal members owned the fishing rights; there was no question about that in 1920, or for all the years before." Old-timers spoke of Chief Charley as a man of quiet dignity who merited and was freely accorded great respect by those who knew him. His regal stature and his aura of authority made him a popular orator at the annual Pacific County Pioneer Picnics. George Charley was born in 1864 at Bruceport. He had exhibited the traits of leadership early in life, and as a young man had performed many deeds of valor, such as assisting in the North Cove Life Saving Service. He married Caroline Matell, born at Chinook, and they were the parents of 12 children. As chief of his people, Charley acted as guardian over 28 families, instigated work projects for the benefit of his people, and made sure the children attended the schools for Indians. He was active in Indian Affairs and was well known from the Columbia River to Port Angeles. Chief Charley is pictured here in a ceremonial headdress, holding a hand-forged knife inherited from his father, "Lighthouse" Charley Ma-Tote. The knife was a gift from Capt. Robert Gray, the first American to make contact with the Chinooks in the late 18th century. On December 17, 1935, when he was 75 years old, Chief Charley was fishing alone with a dip net at the mouth of the Quinault River when a giant breaker swept him out to sea. (PCHS.)

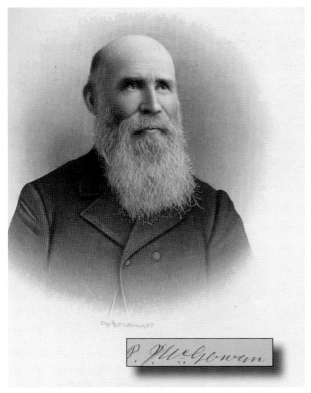

Patrick J. McGowan
In 1861, Patrick "P.J." McGowan began the first salt-salmon packing company in Washington Territory. In the mid-1880s, he converted to a canning operation and established McGowan, a company fishing/cannery town that included houses, a store, church, school, and even a golf course. Eventually, four McGowan canneries—one for each of his sons—dotted both sides of the Columbia River. (EFC.)

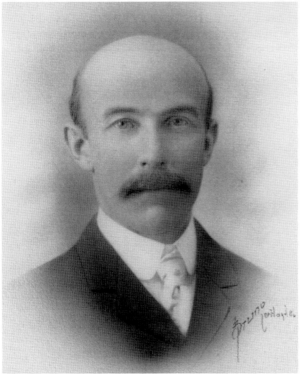

Henry McGowan
In his father's declining years, youngest son Henry McGowan managed the P.J. McGowan interests, transferring the cannery operation to Ilwaco. He served two terms (1906 and 1908) in the Washington State Legislature, championing legislation for Washington fisheries. One favorite family story tells of Henry's first automobile, a 1917 Buick, which he could start but did not know how to stop. This led to his circumnavigating his circular drive until the gasoline was used up.

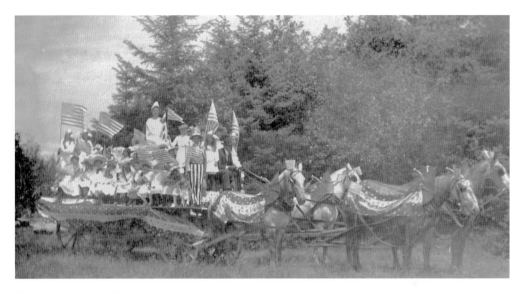

Chinook Liberty Wagon

In the early 20th century, the most anticipated event of the year in Chinook was the Fourth of July Liberty Wagon. Uncle Sam and the Goddess of Liberty waved to onlookers from a wagon festooned with red, white, and blue bunting and pulled by beribboned stallions. At each home, children climbed aboard and enthusiastically waved small flags as they headed for the grand picnic in the schoolhouse grove.

Angus Bowmer

Play director Angus Bowmer (third from right) is seen here on the set of the Chinook School's 1930 production of *Penrod*. Bowmer, a victim of the 1928 bank failure, had secured a teaching position at the school with an annual salary of $1,800. He saved to complete his education at the University of Washington, went on to teach at Southern Oregon College, and, in 1935, established the Oregon Shakespeare Festival in Ashland. (Krager Family Collection.)

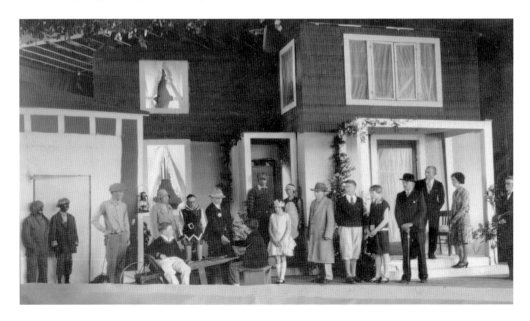

Albion Gile

In 1907, Albion Gile bought his family's Chicona Farm in Chinook and began to breed registered Guernsey cattle. Soon, Eastern breeders were improving their herds by purchasing "Gile's Golden Guernseys." A little over half a century later, the Washington State Guernsey Breeders' Association awarded Gile a gold plaque for his outstanding contribution to the nation's cattle program. Gile also organized the Chinook Packing Company, a mainstay of Chinook prosperity for nearly 100 years.

The Prest Family

Amanda and Jasper Prest, pictured here with children (from left to right) Lisa, Johnny, and Rita, lived in Chinook in the late 19th and early 20th centuries. Jasper Prest was in the fish trap business with H.S. Gile and was a founder of the Chinook Hatchery, the first salmon hatchery in Washington. The Prests' large home at the east end of Chinook, though no longer in the family, is still a showplace of the community. (DWC.)

Mary Ann and Isaac Whealdon

According to a family story, Quakers Mary Ann and Isaac Whealdon headed west in 1847 after Isaac, who enjoyed playing the fiddle, was told that the devil was in the music box and that he would have to choose between his religion and his fiddle. Mary Ann said afterwards it was one of the best trips she had ever taken. It took six months for them to get from Ohio to Oregon, and every night on the journey they had a campfire, with Isaac playing the fiddle. Eventually, they moved to the seacoast north of the Columbia, buying the James Johnson land claim and house for $1,000. The 640 acres, first called Whealdonsburg, encompassed much of what would become Ilwaco. Their influence in the town is still reflected in street names that include Quaker and the first names of their daughters, Elizabeth, Eliza, and Adelia.

L.D. Williams (OPPOSITE PAGE)

L.D. Williams was born in Wales in 1853 and came to the United States when he was 17. After working on a farm in New York while he finished high school, he followed some of his countrymen to Ohio, where he worked in the steel rolling mills. He then made his way to San Francisco, where he worked as a carpenter. Meanwhile, his brother Capt. Rees Williams had built a hotel in Ilwaco and urged L.D. to move north and help run it. In Ilwaco, L.D. met Eliza Whealdon, daughter of pioneers Isaac and Mary Ann Whealdon. They married in 1879 and raised five children. In 1894, L.D. left the hotel business and opened a feed store on First Street, which he later expanded to include groceries and general merchandise. According to his granddaughter Virginia Williams Jones, "Grandpa loved and believed in work. He ran the L.D. Williams Store for 26 years, was county commissioner for 11 years, served as mayor of Ilwaco, as postmaster, and as pilot commissioner. He was a pillar in the community." When he finally retired in 1920, L.D. said, "I have been asked by my friends what I am going to do now but have not yet decided whether I will file for president or raise carrots." For more than 70 years, the descendants of L.D. and Eliza have honored their pioneering forebears at the Williams Family Reunion, held each September on the Peninsula with attendance now numbering well over 100.

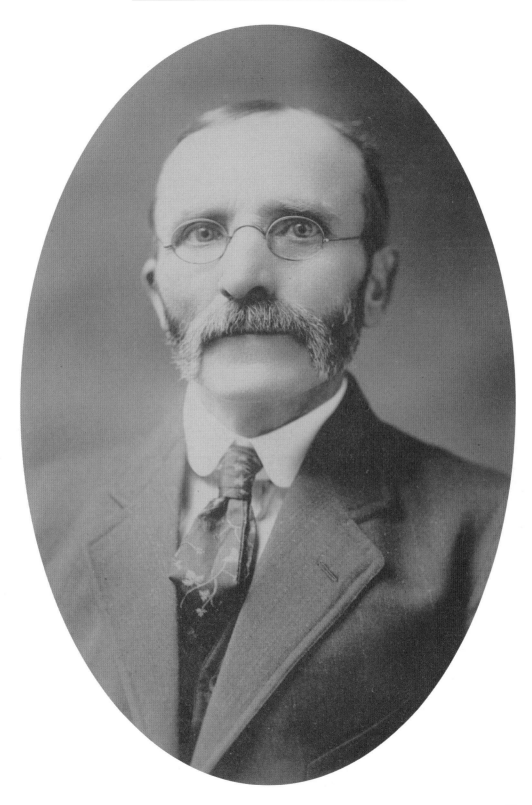

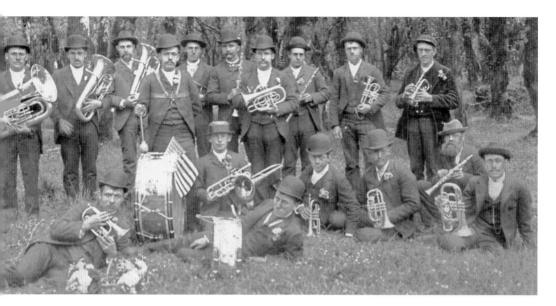

Ilwaco Silver Cornet Band, 1894
As far as it is known, this was the only cornet band ever established on the Peninsula. The members of the 1894 Silver Cornet Band of Ilwaco included, from left to right, (first row) Dr. Parks, William Brumbach, Claude Hall, Astor Seaborg, Fred Marden, Professor Jackson, and Frank Marden; (second row) William Hall, Otto Hall, Clarence Hutton, J.A. "Andy" Howerton (see page 24), Amon Markham, Edward Becken, William Suldon, Jesse Timmen, Henry McNabb, and George Gaither.

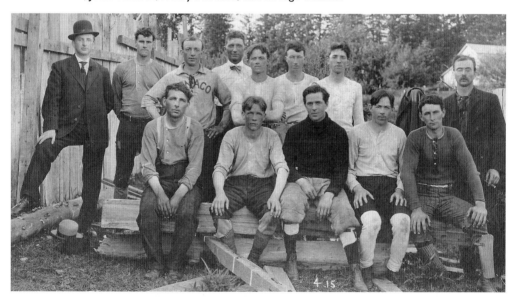

Ilwaco Soccer Team, 1903
The 1903 Ilwaco soccer team was part of a five-county league, which, considering transportation limitations at that time, must have posed many logistical and scheduling challenges. Pictured here are, from left to right, (first row) Daniel Markham, Everett "Spider" Samples, Astor Seaborg, George Kofoed, and Joseph Markham; (second row) manager Ben Wise, Jack Grable, Perry Graham, Roy Herrold (see page 12), Claude Kofoed, Frank Embree, Nels Simmons, and Al Osborne

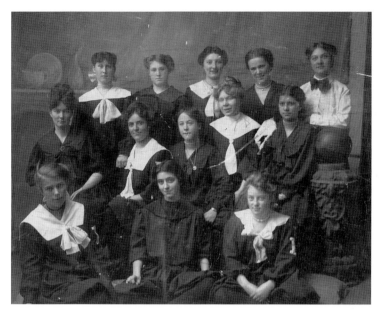

Ilwaco Basketball Team, 1905–1906
Although none of the team members is named on the back of this photograph, its very existence attests to the forward-thinking physical education opportunities offered to the young women of Ilwaco High School.

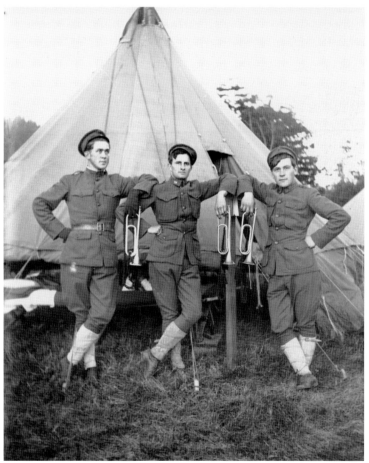

World War I Buglers
During World War One, Fort Columbia's population exceeded that of neighboring communities. It operated like a small town, with a hospital, firehouse, theater, jail, and generator plant. Beyond being soldiers, the men were also bakers, barbers, gardeners, and musicians. Although highly regimented, they still had time for fun. The baseball team played neighboring towns, and local women were invited and trucked to the fort for dances.

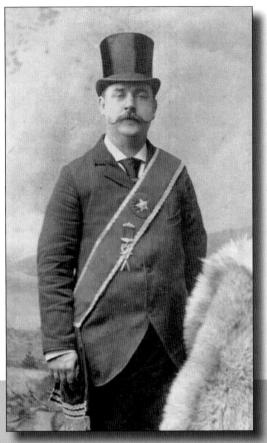

Alfred E. King

Alfred E. King was one of the movers and shakers of early Ilwaco. He was cosigner for the incorporation of the Ilwaco Cemetery Association in 1892, and he helped in the formation of the Aberdeen Packing Company the following year. This successful wholesale/retail outlet soon outgrew its first wooden building, and the owners built a two-story brick building, now known as the Doupé Building (below). It was while King was working as that business's bookkeeper that he was shot in the arm during an altercation between the gill net and trap fishermen—one of several such incidents that constituted the "Gillnet Wars" (1884–1910) along the Ilwaco waterfront. From 1903 to 1906, King served as both mayor and justice of the peace in Ilwaco. In later years, he spent summers in Ocean Park at King's Haven, which is still owned by his descendants.

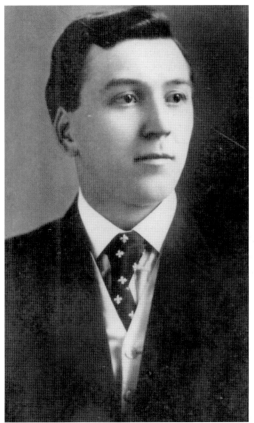

Joseph "Joe" Doupé

Joseph "Joe" Doupé and his three brothers came to America from Limerick, Ireland, in the 1890s. Joe and brother Harry dreamed of owning a store and, in 1919, after years of hard work, they bought the Aberdeen Packing Company Store on the corner of First and Spruce Streets in Ilwaco. There, they opened the Doupé Brothers Hardware Store. Joe ran the hardware department, and Harry managed the ready-to-wear and dry goods departments (below). Much of the hardware stock they carried was specifically for fishermen, including materials for boat and net repair as well as fishing gear (some of which was specially manufactured by Joe to meet local requirements). The two-story brick building, with its distinctive interior balcony, continues to dominate downtown Ilwaco. Although it has had several owners since the Doupé family sold it in 1974, it continues to carry the Doupé Brothers' name.

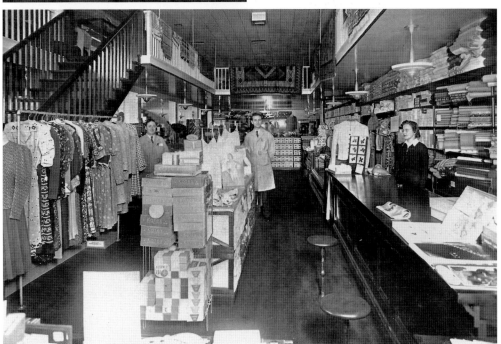

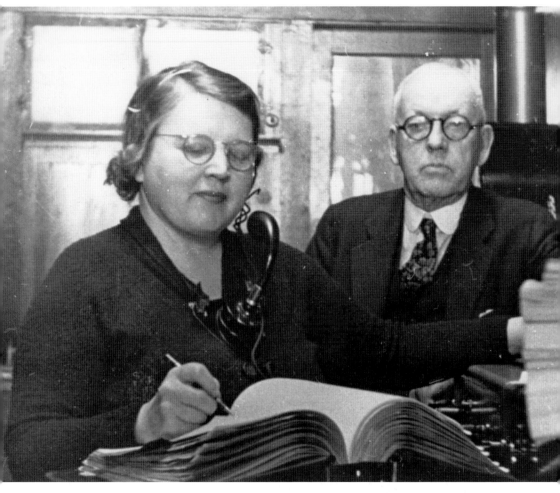

Jenny Sankela and J.A. Howerton

J.A. "Andy" Howerton owned a general merchandise store that advertised "Undertaking a Specialty;" fished in Alaska; and, in 1890, began Ilwaco's first newspaper, the *Advance*, which he sold two years later to the *Pacific Journal* when it moved from Oysterville. He is best known, however, for establishing the Ilwaco Telephone & Telegraph Company, the first utility to service the entire Peninsula. The company began in 1903, when Howerton's brother-in-law needed a way to contact his fishing scow on the waterfront. Howerton rigged up a line between the scow and his brother-in-law's home and installed a two-way crank telephone. When other local businessmen decided that they, too, wanted telephones, the Ilwaco Telephone & Telegraph Company was born. Howerton soon installed a three-mile line to Chinook; hooked into Pacific Telegraph & Telephone lines by means of an underwater cable to Astoria, Oregon, for the company's first long-distance connection; and then extended the service east to Megler and north to Oysterville. After Howerton's death in 1942, his sons ran the business. By 1972, they had incorporated under the name Telephone Utilities and owned 22 subsidiaries that provided service to 60,000 customers in four states. Andy Howerton is shown here with longtime office manager Jenny Sankela, who kept the books and ran the switchboard.

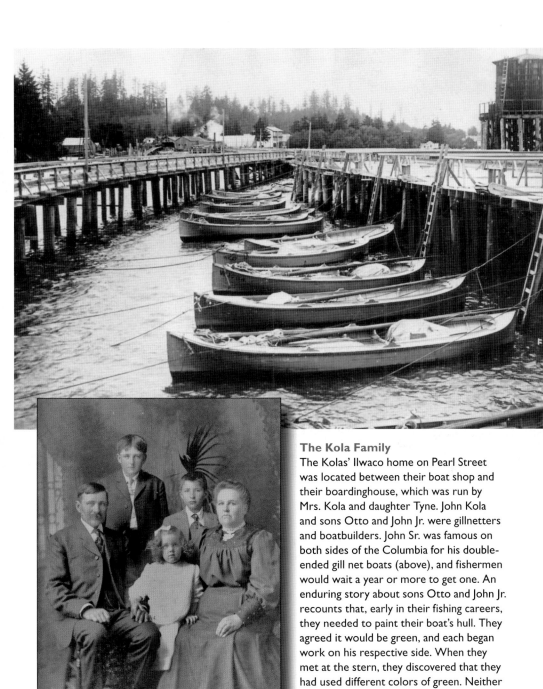

The Kola Family

The Kolas' Ilwaco home on Pearl Street was located between their boat shop and their boardinghouse, which was run by Mrs. Kola and daughter Tyne. John Kola and sons Otto and John Jr. were gillnetters and boatbuilders. John Sr. was famous on both sides of the Columbia for his double-ended gill net boats (above), and fishermen would wait a year or more to get one. An enduring story about sons Otto and John Jr. recounts that, early in their fishing careers, they needed to paint their boat's hull. They agreed it would be green, and each began work on his respective side. When they met at the stern, they discovered that they had used different colors of green. Neither would back down, and they never spoke to one another again. They continued fishing together, however, each from his own side of the boat.

Frank Turner

Frank Turner was publisher and editor of the *Ilwaco Tribune* from 1925 to 1942. Perhaps because he grew up in Oysterville and South Bend at a time of history-making turbulence in Pacific County, he had an abiding interest in the stories of early times. After Turner sold the *Tribune* to his daughter and son-in-law Martha (see page 27) and Dick Murfin (below), he continued writing his popular "From Auld Lang Syne" column. In 1952, the *Tribune* was presented with a special award by the Washington State Historical Society for being "the weekly newspaper rendering the most constructive service toward the preservation of Washington History." (Both, Murfin family photographs.)

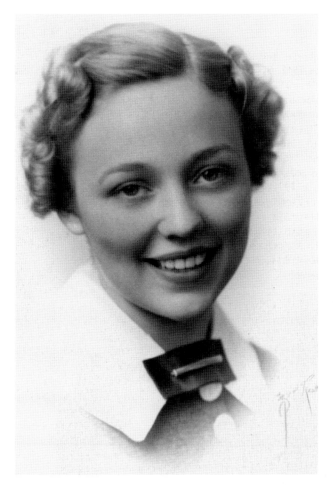

Martha Turner Murfin

Martha Turner Murfin's first job was as a printer's devil, working for her father, the publisher of the *Ilwaco Tribune*. At age 10, when she was big enough to operate the linotype machine, she began to learn the newspaper trade in earnest. "I never got a paycheck," she said. "What I got was to go to college!" Her passion was basketball and, despite her diminutive four-foot-ten stature, she graduated from the University of Washington with a degree in physical education. When her father retired from the newspaper in 1942, Martha and her husband, Dick, took over the business, putting out the weekly paper until their own retirement in 1975. By then, Martha had already begun turning her attention to the children of the Peninsula, particularly to those in need. She saw to the establishment of infant and toddler child care, was the impetus behind a day care center near the high school for use by teenaged mothers, and helped the local Boys and Girls Club get started. She was a longtime Sunday school teacher and volunteered in the primary grades at Long Beach School, helping struggling readers. Every school-age child in need knew "Mrs. Muffin" as the one who could help replace an outgrown jacket or a pair of falling-to-pieces shoes. More importantly, she got other people involved. They turned over money and donations to her, knowing that she would find the best possible use for them. Her garage became a makeshift warehouse, from which food could be distributed through various service organizations. She was given awards by the governor and by the American Association of University Women, and when the new school was built in Long Beach, its library was named after her. Murfin was still actively assisting needy families until her death at age 93 in 2011. She had long since been given the affectionate title "Saint Martha" by the community at large. (EFC.)

**Dr. Lewis Neace and
Dr. John Campiche**
Portraits of Dr. Lewis Neace and Dr. John Campiche hang in the lobby of the Ocean Beach Hospital in Ilwaco. The two men shared a practice for several years in the 1950s and were founding board members of the hospital from its modest beginnings in an old house in Seaview. Neace served the community for 51 years, giving free physicals to school athletes in Ilwaco and nearby Naselle. Campiche found time to build an ocean-going boat and, after retirement, took up a second career as a watercolorist. "They were the last of the old-time physicians," said nurse Mary Ann Markham. "Those two men took care of everything that came along. They didn't just take care of physical ills—they walked right into our hearts and touched our souls." (Both, Sydney Stevens photographs.)

John G. Williams Jr.

On the Long Beach Peninsula, he was called just "Admiral Jack," and everyone was proud of him—a local boy who made good. John G. Williams Jr. was born in 1924 in Ilwaco, the great-grandson of the pioneer Whealdons (see page 18) who had settled there in the 1850s. After attending Ilwaco High School, Williams graduated from the US Naval Academy in 1946 (as a member of the class of 1947) and from the Submarine School in 1949. In the years that followed, he served on the USS *Pompodon*, the USS *Chivo*, and the USS *Stickleback*. He was commanding officer of the USS *Sterlet*, USS *Haddo*, and USS *Daniel Webster* as well as of a squadron at Rota, Spain. In 1981, he was promoted to admiral and assigned as chief of Naval Material. Over the course of his career, he was awarded the Distinguished Service Medal, Legion of Merit, Navy Commendation Medal, and Meritorious Service Medal. (He had so many awards—many of which were displayed around the walls of his garage—that he was sometimes called "Plaque Jack.") He retired from the Navy in 1983 and moved back to the Peninsula with his wife, Dorothy, also from a pioneer Peninsula family. He was soon elected trustee of the Ocean Beach School District. While serving on the school board, Williams realized that the existing state and federal funding for public schools was not sufficient to provide anything beyond the barest of programs. Believing that it was incumbent upon local communities to provide enhanced education opportunities for the Peninsula's children, Admiral Williams worked to establish the Ocean Beach Education Foundation, inaugurated the year of his death in 1991.

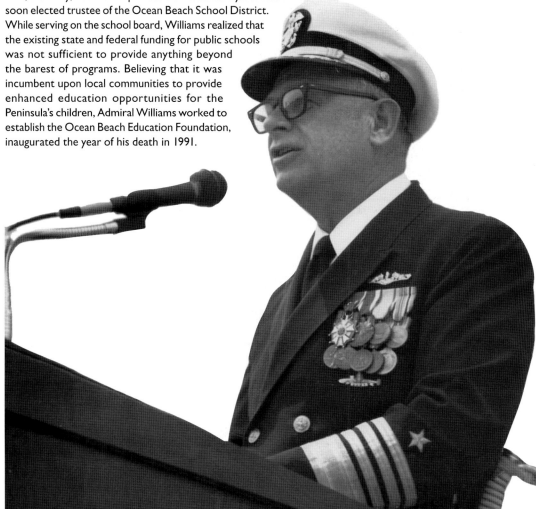

Carl Aase

Carl Aase served as the Peninsula's school superintendent from 1948 to 1969, first in the Ilwaco School District and then in the Ocean Beach School District (a consolidation of the Ocean Park, Long Beach, Ilwaco, and Chinook School Districts). He was greatly respected by students and staff, and the Ilwaco High School gymnasium was named in his honor.

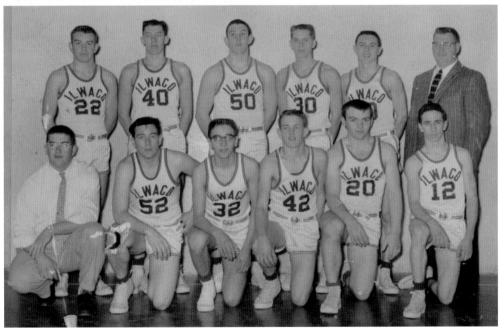

Ilwaco High School Champions, 1959
In 1959, after an undefeated season, the Ilwaco High School boys' basketball team went on to win the Washington State Class B championship. Pictured here are, from left to right, (first row) manager Charles Shier, Lynn Worthington, Gary Tetz, Dennis Oman, Bob Bales, and Al Dobbs; (second row) Don Bales, Steve Gray, Ken Sugarman, Jim Peterson (see page 32), Bill Jacobe, and coach Don Lee. (Dennis Oman Collection.)

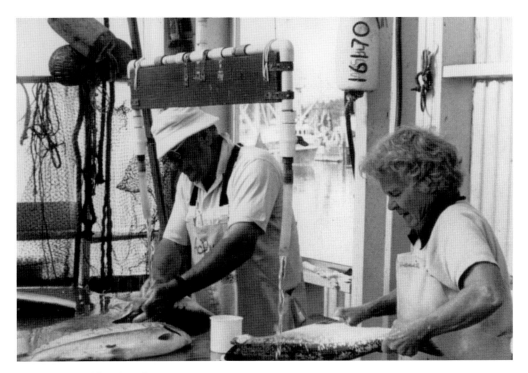

Al and Jessie Marchand

Al and Jessie Marchand set the standard for fresh fish—retail, wholesale, buying, or selling. They purchased the Ilwaco Fish Company in 1962, renamed it Jessie's Ilwaco Fish Company, and quickly became well known and well respected in the seafood processing business. They worked the line side-by-side with their crew, and Jessie also handled their summertime retail operation. Now owned and operated by the next generation of Marchands, the colorful red building (below) at the west end of the wharf is a well-loved institution in Ilwaco. Jessie's distributes worldwide and is the United States's largest buyer of Albacore tuna. (Marchand Family Collection.)

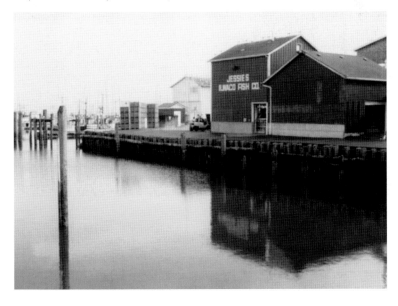

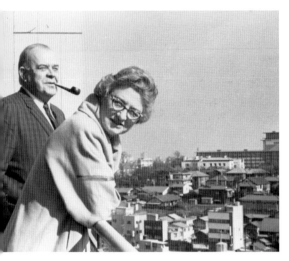

Arnie and Rhea Suomela
From 1961 to 1966, Arnie and Rhea Suomela lived in Japan while he served as fisheries attaché in the American Embassy in Tokyo. It was the culmination of a 40-year career, during which Suomela had held prestigious positions like director of fisheries in Oregon and commissioner of the US Fish and Wildlife Service. He is remembered for personally rescuing salmon populations trapped during the Grand Coulee Dam construction.

James Peterson
James "Jim" Peterson, a graduate of Ilwaco High School, had a distinguished career far from the Peninsula but never forgot his roots. As chief executive officer of Haemonetics in Switzerland, Peterson began a summer internship for Ilwaco High School students. Though they were required to take French, students were paid for their work, were exposed to an international career, and got a firsthand look at Europe. (Erik Fagerland photograph.)

Malcolm and Ardell McPhail
Malcolm and Ardell McPhail bought a derelict cranberry farm of seven semi-productive acres in 1981. They have continued to buy and develop cranberry bogs, and CranMac Farms is now the largest cranberry operation in Washington State, with 106 acres in cultivation. As industry leaders, the McPhails helped form the Pacific Coast Cranberry Research Foundation, a unique growers' cooperative headquartered on the Peninsula. (McPhail family photograph.)

The Anderson Women
Sisters Heidi Anderson Clarke and Sarah Anderson Taylor, along with and their mother, Melinda "Sue" Anderson (pictured from left to right), all teach in the Ocean Beach School District. Sarah is the intervention specialist and cross-country coach at Ilwaco Middle/High School, and Heidi and Sue work together at Long Beach Elementary School as a fifth- and sixth-grade team-teaching duo. The three have spent an impressive 75 years total in the local schools. (Anderson family photograph.)

Noreen Robinson

Noreen Robinson was a "just do it!" kind of woman. In 1982, concerned about the gradual decline of Ilwaco, she and her morning coffee buddies decided that a museum might regenerate some interest in the community. She called the Smithsonian for advice, convinced the city to let her use an abandoned building, and began the Ilwaco Heritage Museum, which rapidly grew into the highly respected Columbia Pacific Heritage Museum.

Nancy Lloyd

Often referred to as a "Renaissance woman" Nancy Lloyd is an author, illustrator, artist, and historian. She is recognized for her distinctive, whimsical style—both in writing and in two-dimensional art—often putting a new spin on old information. She has produced T-shirts, visitors' information kiosks, leather maps, and paintings in a variety of media, and she has also written several books focusing on the local area.

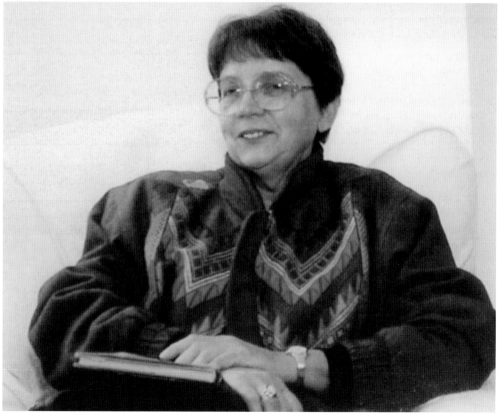

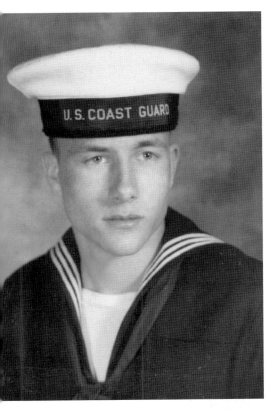

Mark Dobney
Mark Dobney joined the US Coast Guard at 17 in 1972 and completed his 30 years of service as officer in charge of the National Motor Lifeboat School at Cape Disappointment. He had promised his wife that they would stay in one place when he retired. "We love it here on the Peninsula," says Dobney, who continues to work for the USCG as a civilian rescue coordinator.

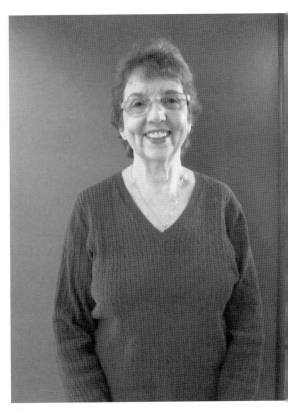

Cherry Harding
When Cherry Harding and her husband retired to the beach in 1989, she immediately became involved in the community. Cherry has served on the boards of the Water Music Festival and the Friends of the Library. She spends two days a week in elementary school classrooms, another day at the Humane Society, and a fourth day at the Columbia Pacific Heritage Museum. She is the Peninsula's quintessential volunteer. (Sydney Stevens photograph.)

The Karys

Randall "Randy" Kary and his son Tony are second- and third-generation commercial fishermen out of Ilwaco. "All of the Karys—my father, my uncles, my cousins—all of us have fished," says Randy. According to his wife, Tracie, "It's in their DNA." But, as regulations get tighter, expenses go up, and fishing seasons become shorter, Tracie maintains hope that Tony will eventually choose another career. (Tracie Kary photograph.)

The Schenk Family

Since the early 1960s, four generations of Schenks have been in the charter-fishing business out of the Port of Ilwaco. Representing generations two, three, and four on their boat, the *Four Sea'sons*, are, from left to right, (first row) Dan, Ryan, James, Justice, and Eli; (second row) Pat Jr. and Pat Sr. (Grandpa Pat), who has made 8,000 Columbia River Bar crossings. "But," he points out, "unlike commercial fishermen, I'm home every night!" (Schenk family photograph.)

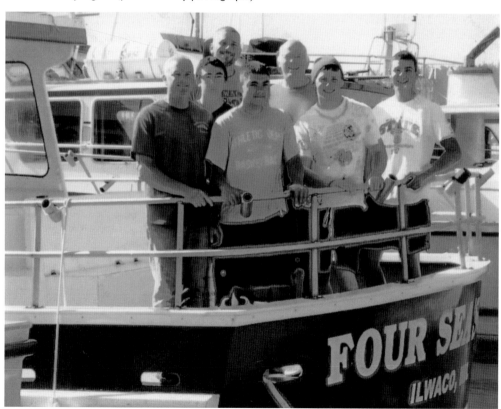

Wesley "Geno" Leech
In his poem, "I Miss the Fish But I Don't Miss The Fishin,'" fisher poet Wesley "Geno" Leech, of Chinook, says: "I don't miss the buck / the bang and the roll / Kidney punchin' Nor'westers and nut numbin' cold / Pickin' Dog Shark from every mesh in the net / Or sortin'a tow while you stand on your head. Nah, there ain't much about fishin' that I really miss / Except bringin' home zip locks of fresh filleted fish." For nearly 40 years, Leech has worked worldwide on commercial fishing vessels, merchant ships, and salvage ships. His rank is able seaman, but he prefers to call himself a "deck ape" and takes pride in working hard and well at "grunt jobs." He has rubbed shoulders with "heroes, down-and-outers, boozers, and dreamers." They are his colleagues and friends, are often subjects of his poems, and in the 1990s were his first audiences—crew members listening over a ship's radio. Leech commits each poem to memory and his performances treat the eye as well as the ear as he "dances" his way through the words. He performs at poetry and folk gatherings all over the United States, though his day job is still involved with ships and working at sea. (Leech Photo Collection.)

Luke Jensen

Luke Jensen was one of four crew members on the 70-foot fishing boat *Lady Cecelia* that disappeared on March 10, 2012. They were 17 miles off Leadbetter Point, returning home with an estimated 70,000 pounds of fish. An oil sheen and a fully inflated, but empty, life raft were all that were found. Jensen was 22 years old and had been fishing, one way or another, for his entire life. On a break from his studies at Humboldt State University, he had come home to Ilwaco to do what he loved most: fish. His memorial service was crowded with friends of all ages and from all walks of life. From his 80-year-old, next-door neighbor ("Luke was my best friend.") to classmates, fishing buddies, teachers and relatives, they came to honor his memory and to tell how he had touched their lives—a powerful and poignant reminder that it does, indeed, take a village. Local songwriter Mary Garvey paid tribute to him in the final verse of her song about the tragedy: "So here's to the *Cecelia* and her brave and gentle crew / And mostly to Luke Jensen, he's the only one I knew / This was their joy and calling and the sea was their delight / But the whole town is in mourning since their ship went down that night." (David Jensen photograph.)

CHAPTER TWO

On the Shores of Willapa Bay

The eastern shoreline of the Peninsula bumps against Willapa Bay, one of the cleanest large estuaries in the continental United States and one of the largest oyster-producing areas in the world. Along its 20-mile length are two settlements—Oysterville and Nahcotta—and a scattering of individual residences.

Oysterville was established in 1854 by men eager to ship the bay's abundant native oysters (*Ostrea lurida*) to clamoring San Francisco markets. The town boomed, quickly becoming the county seat and the most populated settlement in the region. By 1890, however, the oysters were played out, the town lost its status as county seat, the population disappeared, and Oysterville gradually became a ghost town. Years later, it was placed in the National Register of Historic Places, and it is now one of the Northwest's major heritage tourism destinations.

Nahcotta came along a generation and more after Oysterville. It was founded in 1889 as the terminus for the newly built Ilwaco Railroad. A deepwater channel close to shore made for easy water and rail connections with communities across the bay to the east and north. The town soon became the transportation hub of the Peninsula. Assured of easy access to tidelands and a convenient method of shipping their products, the oystermen, too, made Nahcotta their new headquarters. They redoubled their efforts to revive the industry, first with Eastern oysters (*Crassostrea virginica*) and, ultimately, with Japanese oysters (*Crassostrea gigas*).

Today, opening houses, canneries, and hatcheries line the Nahcotta dock, and gigantic piles of oyster shells, scheduled for recycling, punctuate the bayside landscape. Either directly or indirectly, most of the workers of the area—biologists, boat builders, ecologists, and restaurateurs—have connections to the oyster industry.

Oystermen compare oysters to the proverbial canary in the mine shaft: a healthy oyster industry indicates a healthy ecosystem, which, in turn, ensures the sustainability of the area's fishing and timber industries and provides an inviting destination for outdoor enthusiasts and tourists. The people who live along Willapa Bay are committed to its care.

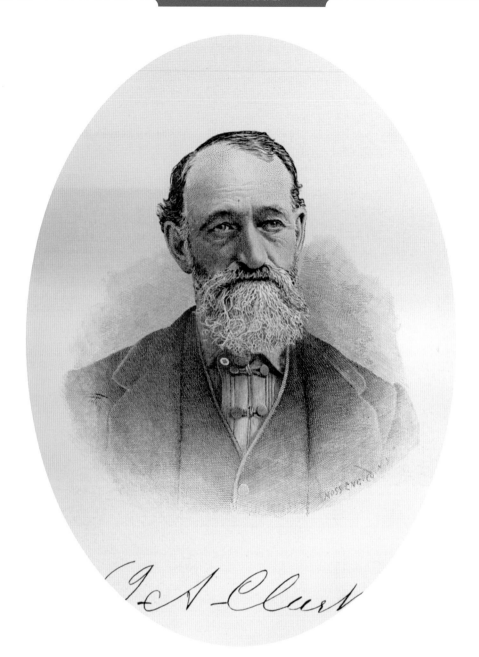

Isaac Alonzo Clark

Isaac Alonzo Clark, cofounder of Oysterville with R.H. Espy (see page 41), platted the bayside village and became its first storekeeper. He was also an oysterman, but according to his cohorts, he was a rather timid boatman. When a storm was brewing out on the bay, he often put in at a protected cove near Leadbetter Point. As the other plungers headed homeward, they would see Clark's boat, *Dr. Stackpole*, hunkered down for the duration. The cove is still called "Stackpole Harbor." A staunch Methodist, Clark eventually tired of Oysterville's boomtown character and, in 1883, moved five miles south, platting the townsite of Ocean Park for the Methodist Episcopal Church of Portland. (EFC.)

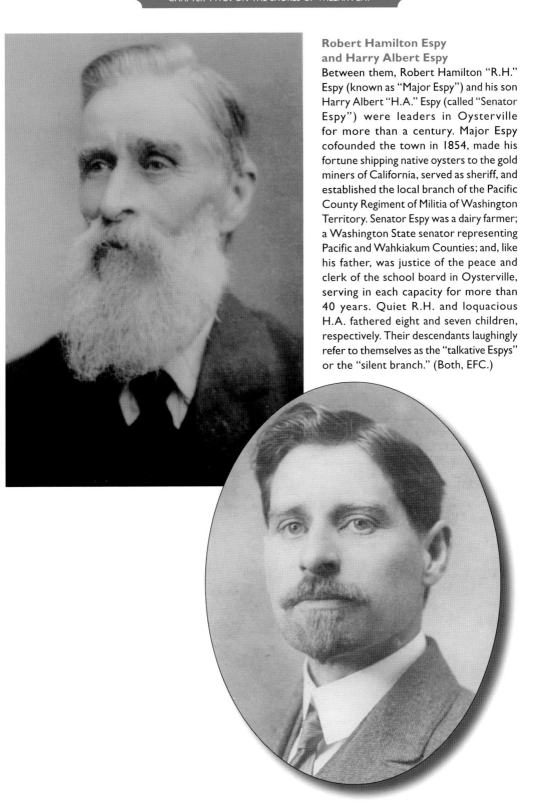

Robert Hamilton Espy and Harry Albert Espy

Between them, Robert Hamilton "R.H." Espy (known as "Major Espy") and his son Harry Albert "H.A." Espy (called "Senator Espy") were leaders in Oysterville for more than a century. Major Espy cofounded the town in 1854, made his fortune shipping native oysters to the gold miners of California, served as sheriff, and established the local branch of the Pacific County Regiment of Militia of Washington Territory. Senator Espy was a dairy farmer; a Washington State senator representing Pacific and Wahkiakum Counties; and, like his father, was justice of the peace and clerk of the school board in Oysterville, serving in each capacity for more than 40 years. Quiet R.H. and loquacious H.A. fathered eight and seven children, respectively. Their descendants laughingly refer to themselves as the "talkative Espys" or the "silent branch." (Both, EFC.)

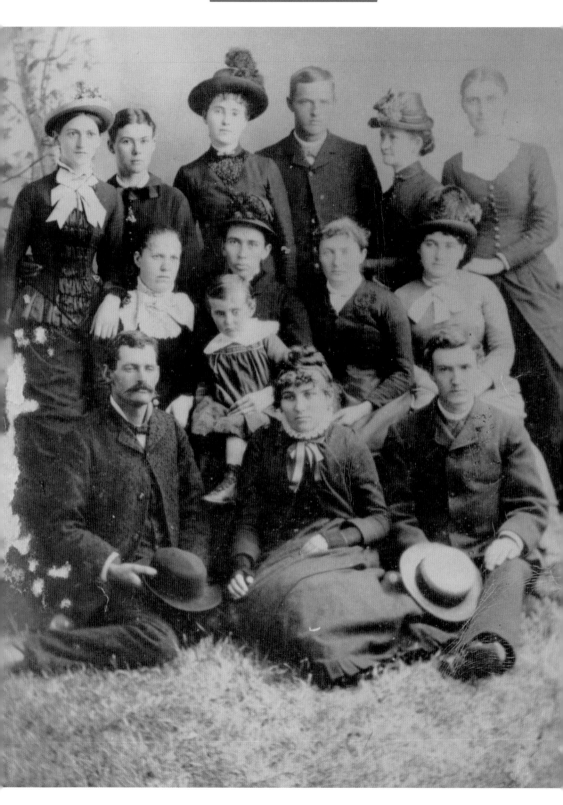

Teachers' Institute, 1885 (OPPOSITE PAGE)

By 1879, Pacific County had 24 school districts, and in a report to the state superintendent of schools, the Pacific County superintendent complained, "The population of Pacific County is scattered over such a wide scope of country that it is impossible, with very few exceptions, for any great number of scholars to be accommodated in any one district, on account of the distance to be traveled in getting to and from school; consequently our schools are mostly small ones . . . " Two years later, a new Pacific County superintendent listed a similar complaint with regard to holding a Teachers' Institute, writing, "It has been impossible with the materials available, and the extreme inconvenience of traveling in this county, to hold a Teachers' Institute, but we are discussing the subject with a view to practical results, if possible at an early date." The "early date" would not be for five more years. The back of this image, labeled "Teacher's First Institute, 1885," identifies the individuals pictured as follows: "Seated with child—Ada Brown Hicklin and small son, John; On her right—Mollie Hutton; On Left—Ola and Effie Gillespie; On the Ground—David English, Ella Tanger, and William Matthews; Standing: Sarah Brand Davis, May Lilly, Emma Bailey Sparrow, Lin Bush, Mrs. Canouse, Rebecca Brown Matthews." (PCHS.)

Joseph H. and Martha Brownfield Turner

Joseph H. Turner, elected in 1884, was the last of the territorial sheriffs in Pacific County. He continued in office for three years after Washington was granted statehood, but did not run for a fourth term. Perhaps this was due to the horrendous Rose murder trial and subsequent lynching, which took place under his watch in 1890. The prominent Rose family of South Bend were friends of the Turners, and when the sheriff arrested John Rose, his son George, and two other men for the murder of Jens and Neilsine Frederiksen, the citizens of Pacific County loudly and impatiently demanded justice. As the trial dragged on, the sheriff grew concerned for the safety of his prisoners and their families. He and wife Martha offered sanctuary in their own home to the Rose women, and Joseph obtained a change of venue for two of the men. However, outraged that the remaining two were to be given a new trial, an angry mob from South Bend gathered outside the Oysterville jail and shot at the prisoners through the barred windows of the building. Though the men sought safety under their bunks, ricocheting bullets killed them both. At the end of his term, Turner moved his family to South Bend, where he served as postmaster until his untimely death due to a heart attack in 1905. He was 59 years of age.

Kate Hulbert Wichser Miller Espy

Affectionately called "Aunt Kate" by all who knew her (though not related to a single soul in all of Washington state), Kate Hulbert Wichser Miller Espy was the third wife of Oysterville's founder R.H. Espy (see page 41). She had first traveled from Wisconsin to Oysterville in 1878 as the mail-order bride of the itinerant Baptist preacher Rev. J. Wichser. She was 40 years old—long since considered an old maid by the standards of the day. For a year after their marriage, the Wichsers lived with the family of Julia and R.H. Espy, and, for the next 10 years, they traveled throughout the wilderness of western Washington Territory, establishing churches as they went. Shortly after Reverend Wichser's death in 1891, Aunt Kate married for a second time, to another Baptist preacher by the name of Miller. As the years passed, she continued writing to her friend Julia Espy and, on occasion, came to Oysterville "for a good and proper visit." In 1907, six years after Julia's death (and two years after R.H.'s divorce from a "fortune hunter"), Kate Hulbert Wichser Miller moved back to Oysterville and married R.H. Espy, widower of her good friend. Aunt Kate had outlived two husbands and was also to outlive the third by a good many years. The Espy grandchildren all remembered that Aunt Kate wore long skirts, high buttoned shoes, and was proud that she could scrape the meat from an apple with her one remaining tooth. Once, when Espy's son Cecil was in his nineties, he and his niece Dale Espy Little (see page 55) were reminiscing about Aunt Kate and her quaint ways. "I think Aunt Kate must be one of the few women who was married three times and died a virgin," Dale remarked. "Not if you knew Father," was Cecil's wry reply. (EFC.)

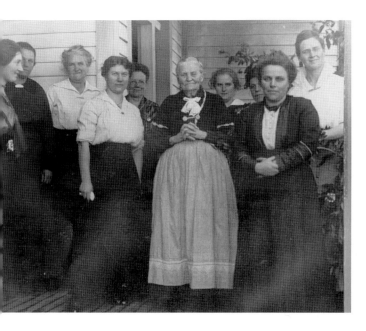

Oysterville Sewing Circle, 1918
From the community's earliest days, the women of Oysterville got together to do their "straight-ahead" sewing. They darned, put in buttonholes, hemmed napkins, or cut out quilt pieces—whatever tedious sort of chore needed doing by the hostess of the day. Pictured here are, from left to right, Beulah Richardson, unidentified, Laura Fisher, Alice Holm, Ina Stoner, Kate Espy (see page 44), unidentified, Helen Espy, Emma Lehman, and Anna Brooks (see page 66). (EFC.)

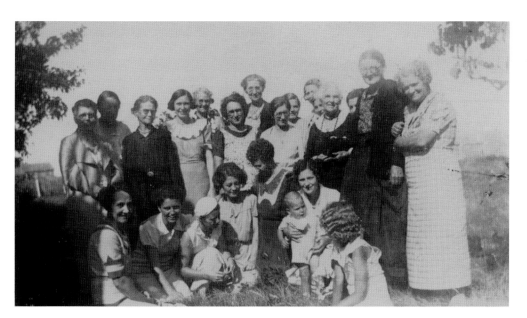

Oysterville Women's Club, 1932
In 1925, the sewing circle organized itself more formally, elected a president, and expanded its interests beyond needle and thread to include buying extras for the school with pennies saved from its "egg and cream money." Pictured here are, from left to right, (first row) Irene Nelson, Dale Espy (see page 55), Muriel "Mona" Espy, Helen Thompson Heckes (see page 60), unidentified, Gyla Kemmer Cannon (holding an unidentified baby), and an unidentified girl; (second row) Helen Espy, Dora Espy Wilson, Mrs. Taylor, unidentified, Myra Fisher, Edith Olson, two unidentified women, Alice Sargant, Ruby Bilodeau (Andrews), Pearl Andrews (Bilodeau), Mary Wirt, unidentified, Maggie Sargant, and Louise Wachsmuth. (EFC.)

Cecelia "Jane" Haguet Johnson (OPPOSITE PAGE)
Cecelia "Jane" Haguet Johnson (Howard) lived south of the Oysterville Baptist Church with her husband, Capt. Jimmy Johnson, and their eight children. Their ninth child was born three months after Jimmy drowned in a boating accident on Shoalwater Bay. Jane, born in 1848, had grown up on her parents' donation land claim near present-day Ilwaco. She was educated at Providence Academy in Vancouver, Washington, and, before she married, she had been one of the early schoolteachers of Pacific County. For her first assignment, she was offered a pig in exchange for a term's work. At school's end, the farmer tethered the pig behind the schoolhouse for Jane to take home to her family in Ilwaco the next day. Unhappily, in the morning she found that a bear had done away with her "salary" during the night.

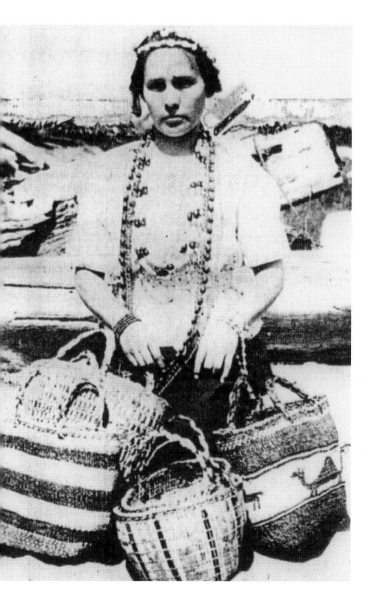

Myrtle Johnson Woodcock
Referred to as "the last princess of Oysterville," Myrtle Johnson Woodcock was the great-granddaughter of both Chief Hoqueem of the Quinaults (after whom Hoquiam, Washington, was named) and Chief Uhlahnee of the Celilo Falls Chinooks, and granddaughter of Hudson's Bay Company employee Capt. James Johnson Sr. When she was born, the chiefs of many tribes arrived in their high-prow canoes bringing gifts in celebration and to honor this descendant of chiefs, this child whose father had recently drowned. In later years, Myrtle was active in the Pacific County Historical Society and, throughout her life, she wrote and published poems reflecting a deep love and understanding of her dual heritage. (PCHS.)

Lewis Alfred Loomis

Lewis Alfred "L.A." Loomis arrived in Oysterville in 1872 and went into the sheep-raising business. An "unfortunate wool-wetting experience" between shore and boat convinced him to build a dock at Ilwaco. Next, he bought stagecoaches to carry mail and passengers the length of the weather beach; bought boats to take mail across the Columbia River and Shoalwater Bay; and, finally in 1889, built a narrow-gauge railroad from Ilwaco to Nahcotta. Loomis was a hands-on manager; he often inspected the line himself, acting as his own section boss, and would not allow replacement of any tie unless it was so rotten that the tip of his gold-headed walking stick went completely through upon striking it. He also sold cordwood cut from his own timberland to the railroad for fuel. He built a fine mansion near Klipsan Beach, which became the "Loomis Station" stop for friends and family. It was Loomis's train, the Ilwaco Railway & Navigation Company (IR&N), that brought tourists to the beach in increasing numbers and opened the way for expanded settlement of the Peninsula.

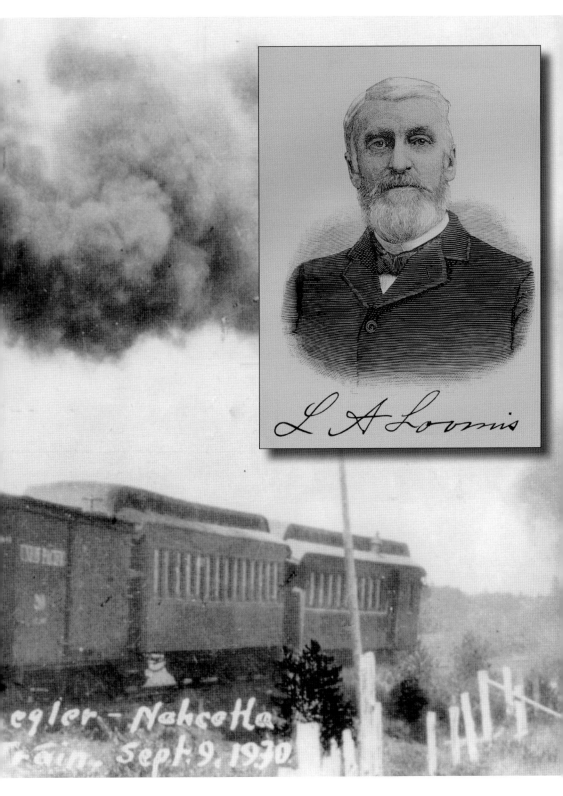

L A Loomis

egler - Nahcotta
Train Sept. 9, 1930

Louis Wachsmuth and the Oysterville Soccer Team, 1880s
According to local lore, soccer was brought to Oysterville in the 1880s by shipwrecked English sailors, perhaps from the *G. Broughton*, *Lammerlaw*, or *Dewa Gungadgar*, which all wrecked between 1880 and 1885 near Leadbetter Point, just a few miles north of Oysterville. In this 1880s photograph, the only identified player is goalie Louis Wachsmuth, seated in the center of the front row with the soccer ball. (WFC.)

Chester "Tucker" Wachsmuth
Several generations of children, including his granddaughter Danielle, consider Chester "Tucker" Wachsmuth the pied piper of Oysterville. From organizing scavenger hunts to inventing Oysterville Whiffle Golf and promoting a modern-day version of the historic Oysterville Regatta, Wachsmuth has rallied all ages around fun at the beach. A fourth-generation Oystervillian, he is proud of his family heritage in the oyster industry of Willapa Bay. (Amy Wachsmuth photograph.)

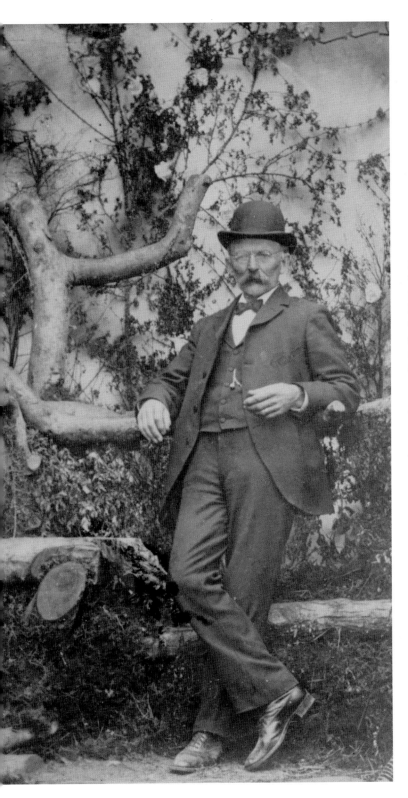

Meinert Wachsmuth

Meinert Wachsmuth, born in Schleswig, Germany, in 1842, shipped before the mast as a cabin boy at the age of 16. By 1858, he had visited nearly every port in the world, but when he saw Pacific County on a potato-buying voyage from California, it was love at first sight. He found employment with the Morgan Oyster Company of San Francisco and maneuvered a transfer to its holdings in Oysterville, where he happily spent the next 66 years. He married, raised his family, bought oyster beds of his own, and was the first man on Shoalwater Bay to experiment seriously with growing eastern oysters after the native oysters failed. His descendants are still in the oyster business in Oregon. (EFC.)

51

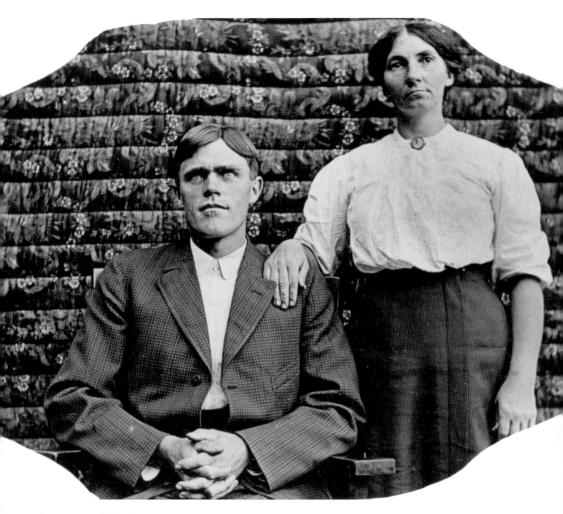

Bert and Minnie Andrews

In 1918, Bert and Minnie Andrews built a small post office and gas station near their home at the foot of Davis Hill, and Minnie became the 13th postmaster of the Oysterville Post Office (the oldest in Washington State). Bert transported the mail to and from the train terminus in Nahcotta, often returning with groceries in answer to requests by his neighbors. Seeing a need, he built the Oysterville Store, and for the next 27 years, he and Minnie catered to the day-to-day needs of the village. During that period, Bert also ran a commercial garage and, years before rural electrification found its way to Oysterville, he provided power to nearby households (about two light bulbs each) with his electric generator. At 10:30 each night, the Andrews' bedtime, it was "lights out!" in Oysterville. (EFC.)

The Caulfield Sisters

From 1923 until the beginning of World War II, four remarkable sisters owned and ran an establishment in Oysterville known variously as the Heckes/Kemmer Inn, the Heckes Place, or just the Boarding House. On the left is Mary Ellner Caulfield, or "Aunt Rye." Born in 1858, she was the eldest of the sisters. Short, spunky, and never married, she was famous for her pies and, as a onetime practical nurse, was in charge of any first aid needs. Second from the left is Alfretta Eva Lindberg, or "Aunt Ev." Born in 1863, she was widowed at a young age. Tall and large-boned, with a quiet, gentle disposition, she was in charge of cooking vegetables and making salads. Third from the left, Edna May Heckes, or "Aunt Nanny," was born in 1869 and was the "boss" of the family. She was kept busy with paperwork and the business of running the inn, and she was also responsible for roasting the meats and cooking the fish. Her husband, "Uncle John," raised the food for the hotel. Finally, on the far right stands Ann Isabel Kemmer, or "Aunt Ann." Ann was born in 1874 and was known for her artistic abilities. She painted on china and canvas, papered the boarders' bedrooms each spring, decorated the cakes, and baked the bread and biscuits. Her husband worked in Portland for the railroad. The sisters' inn, begun in the old Tom Crellin House on the main street of town, was immediately successful, and before long, they purchased several other houses nearby to accommodate their many summer boarders. All of Oysterville took pride in the fact that well-known travel writer Duncan Hines stayed there several times and, in the early 1930s, wrote about the Heckes Place in his popular book *Adventures in Good Eating*. (Anne Cannon Nixon Collection.)

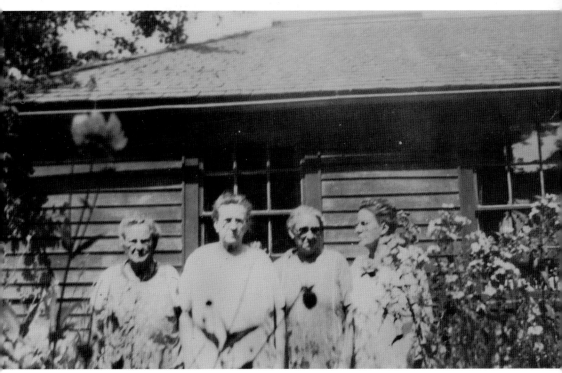

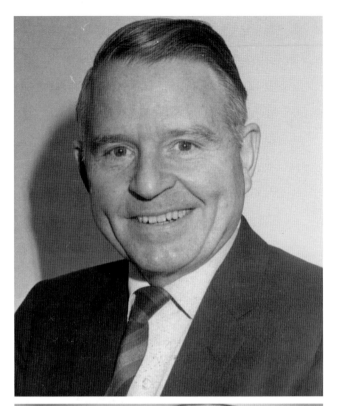

Edwin and Willard Espy
Brothers R.H. Edwin "Ed" Espy (top) and Willard "Wede" R. Espy (bottom) went through school together, attending the first 10 grades at Oysterville's one-room schoolhouse and grades 11 through 12 and a one-semester business course at Ilwaco High School. They received their bachelor of art degrees from the University of Redlands in 1930, when Edwin was 21 and Willard 19. Ed went on to earn a doctorate in theology from Columbia University, became a leader in the international ecumenical movement, and ultimately served as general secretary of the National Council of Churches. He was often referred to as the "Protestant Pope." Willard studied at the Sorbonne; worked for a variety of publications; and, for 16 years, was public relations manager for *Reader's Digest*. He authored 17 books, most concerning wordplay and light verse, and was sometimes called "the bard of Oysterville." On the Long Beach Peninsula, Willard's most acclaimed books are *Oysterville*, *Roads to Grandpa's Village*, and *Skulduggery on Shoalwater Bay* (*Whispered Up from the Graves of the Pioneers*). (Both, EFC.)

Bill and Dale Espy Little

Bill and Dale Espy Little retired to Oysterville in 1972, moving into the house where Dale had grown up and where they had vacationed during the first 41 years of their marriage. They devoted the next 20 years to preservation and restoration projects, including working toward getting Oysterville placed in the National Register of Historic Places, organizing the Oysterville Restoration Foundation, and restoring the Historic Oysterville Church. To keep the encroachments of modern life out of Oysterville, the Littles worked with neighbors and government agencies to develop the Oysterville Design Review Guidelines, ensuring Oysterville's quiet ambience for future generations. The Music Vesper Series, begun in 1979 as a fundraiser for the church, is a continuing legacy to their memory. (EFC.)

Trevor and Louise Kincaid
Prof. Trevor Kincaid, chairman of the Zoology Department at the University of Washington from 1904 until his retirement in 1942, is widely recognized as "the father of the Northwest oyster industry." He spent much of his career experimenting with growth and propagation of Japanese oysters in Willapa Bay. His wife, Louise, frequently accompanied him on his collecting expeditions. Several of his students settled permanently on the Peninsula. (HFC.)

Theodore "Ted" Holway
Theodore "Ted" Holway, a University of Washington biology student, came to Oysterville in the early 1930s. He was one of Prof. Trevor Kincaid's "bright young men," instrumental in reviving the oyster industry in Willapa Harbor. Holway stayed, became a successful oyster cannery owner, and helped to implement a partnership between the Ocean Beach School District and the Chinook Hatchery to provide fisheries education for local high school students. (HFC.)

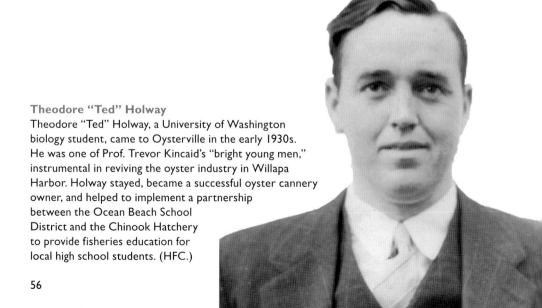

56

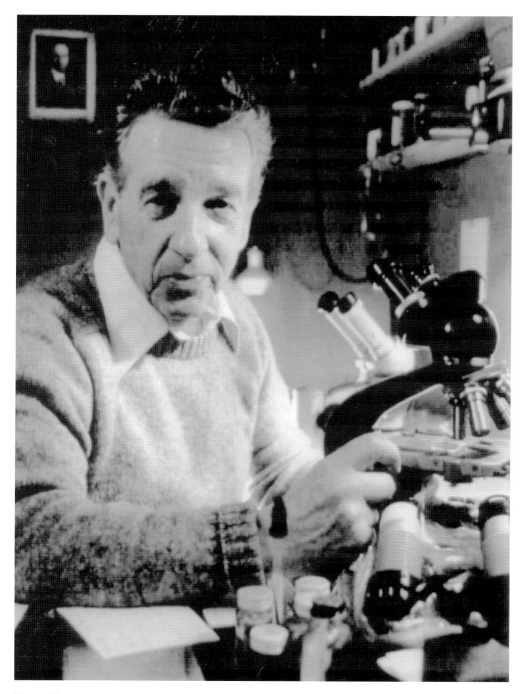

Vance Tartar

Vance Tartar's Oysterville neighbors knew him as a quiet man who was a calligrapher and painter and a staff member of the University of Washington, though he lived four hours from the Seattle campus. What few Peninsula friends knew was that Dr. Tartar, eminent biologist, had made major scientific discoveries while working at the bottom of his garden in the eight-by-ten-foot shed he called "Wits End." There, from 1950 to 1978, he studied the *Stentor coerulus*, a large, trumpet-shaped, ciliated protozoan. (HFC.)

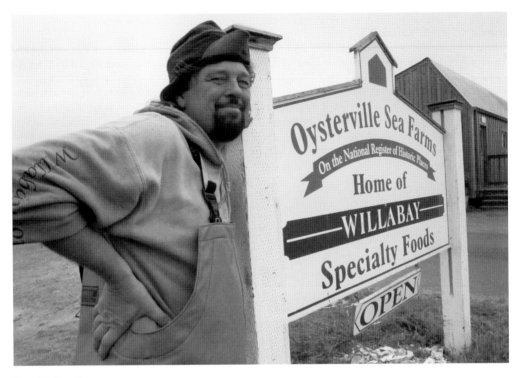

Dan Driscoll
Dan Driscoll, a third-generation oyster grower on Willapa Bay, runs his business, Oysterville Sea Farms, out of the old Northern Oyster cannery that previously belonged to his grandfather Ted Holway (see page 56) and partners Roy Kemmer and Glen Heckes. Driscoll is proud that his is Oysterville's only remaining business that speaks to the town's beginnings, and he enthusiastically puts his profits toward restoring the old building. (Sydney Stevens photograph.)

Susan Holway
Though an Oystervillian born and bred, Susan Holway is also revered in the upriver neighboring town of Naselle, where she helped initiate the annual Finnish American Folk Festival in 1982. Her book of poetry, *Remember Where You Started From*, pays tribute to both locations and to many in between. (HFC.)

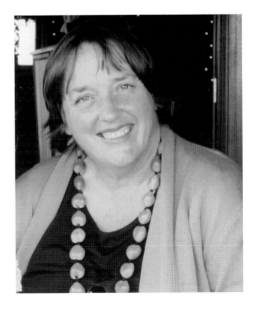

Edwin R. "Bud" Goulter

There are a number of reasons for Edwin R. "Bud" Goulter's reputation as Oysterville's most colorful character. The dozens of corroding vehicles scattered over his swampy acreage have earned his place the nickname "Bud's Rust Farm." During the last decades of the 20th century, cows wandering the gardens and streets of the Peninsula's north-end were called "Bud's Cows," no introduction necessary. (His were the only cows, and his fences were the only ones repaired with twine or string or, once, with panty hose stretched toe-to-toe.) Bud is proud that he can trace his family back five generations to the first doctor in Pacific County, sometimes has his own version of Oysterville's history, and maintains a clear vision of his participation in events since his birth in 1924. Each new "Bud Story," by or about him, invariably elicits a shake of the head and a big smile from his many friends and admirers. (Spike Mafford photograph.)

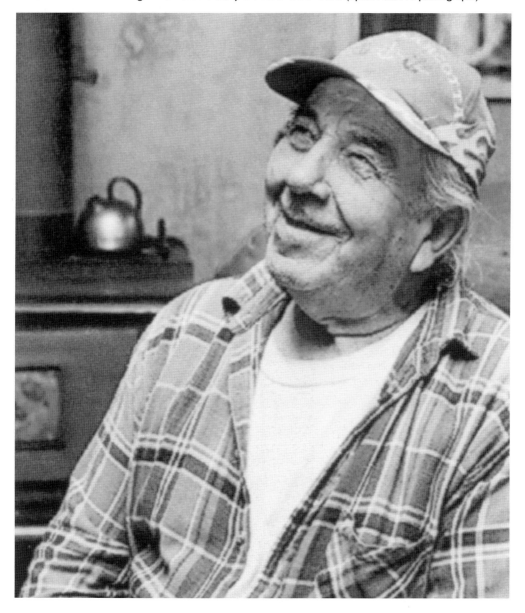

Helen Thompson Heckes
Young Helen Thompson arrived in Oysterville in the early 1920s to teach in the one-room schoolhouse. She recalled how, after school, she was often so busy correcting papers that she would not notice that it was growing dark. "When Theophilus Goulter's turkeys would come to roost in the trees outside, I'd know it was time to walk home." She soon caught the eye of handsome bachelor Glen Heckes, and she gave up teaching to marry him, work at his family's summer boardinghouse, and raise their family. In 1950, prompted, by the birth of a relative with special needs, Helen returned to school for training as a special education teacher. She developed a vocational-style special education class—one of the earliest in Washington—at Ocean Park School, where she taught for many years. (EFC.)

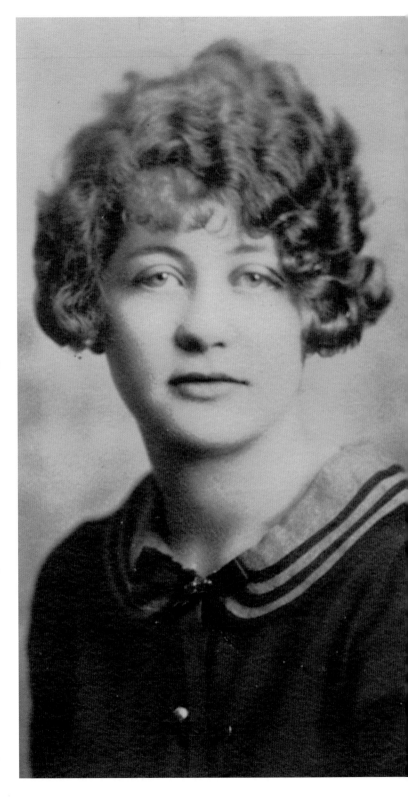

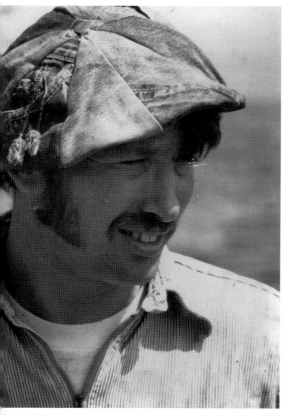

Jim Kemmer

"It's in my blood," says second-generation oysterman and fisherman Jim Kemmer. Brought up first on the tide flats of Oysterville in the company of his father, uncle, and cousins, and later in Ilwaco in the midst of the salmon-fishing industry, Jim is passionate about his work. "I'll be out there until I die," he says, "even if they have to wheel me out in my wheelchair!" (WBO.)

Pete Heckes

Pete Heckes grew up in, on, and around the bay. He shadowed his father, Glen, learning the oyster business by working in every aspect of the Heckes Oyster Company. In addition to the business and a love of oystering, he inherited from his father an abiding interest in people, particularly those connected with the history of the area: the boatbuilders, the Indians, and the old-timers. (Tucker Wachsmuth photograph.)

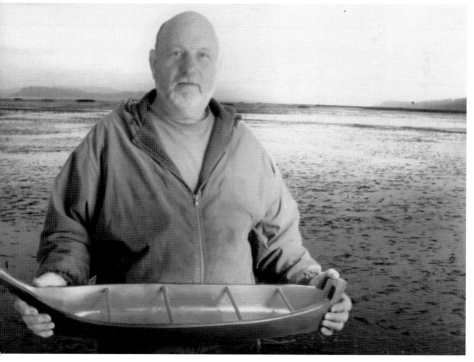

T.J. "Shorty" Wright

T.J. "Shorty" Wright moved his family from Oklahoma to Oysterville shortly before the end of World War II. He and his wife bought the store and post office and settled in with their seven children, including two sets of identical twin boys. Village residents still recall how, on the first day of school, Shorty delivered his six-year-old daughter on horseback, she riding astride behind him. Soon, most of her classmates had convinced their parents that they, too, needed a horse, and for the next decade, nearly every household had at least one pony or rideable nag. In 1947, Shorty helped start the first Long Beach Rodeo (which remains a big event each summer) and, in his declining years, he lived in a small house on the rodeo grounds "to look after things." (Wright family photograph.)

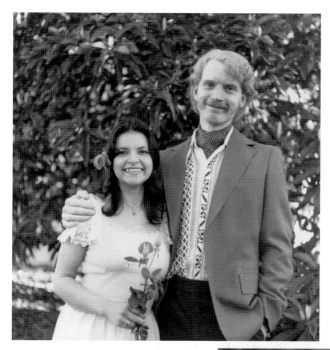

Charles "Carlos" and Sharon Montoya Welsh In the mid-1980s, Oysterville's Charles "Carlos" Welsh was a jazz programmer at radio station KMUN in Astoria. His wife, Sharon Montoya Welsh, taught cooking at Grays Harbor Community College and had coauthored a cookbook titled *Oyster Cookery*. Combining areas of expertise, they began a summer Jazz and Oysters fundraiser for the Peninsula's Water Music Festival. Hugely successful, it outgrew its Oysterville schoolyard venue and, after 25 years, moved to Nahcotta. (Welsh family photograph.)

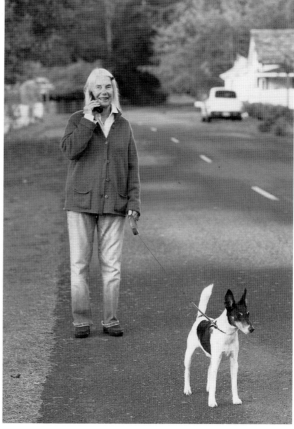

Polly Friedlander Polly Friedlander arrived in Oysterville in the mid-1980s. A great admirer of native son and author Willard Espy (see page 54), she established a nonprofit organization in his name, the Willard R. Espy Literacy Foundation. It provided month-long residencies to numerous writers and artists until its demise nine years later. Friedlander left few traces of her years in Oysterville, except for a lingering air of mystery. (Spike Mafford photograph.)

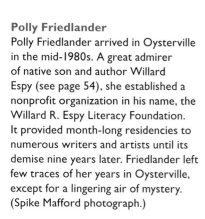

63

Nyel Stevens

In preparation for Oysterville's sesquicentennial in 2004, Nyel Stevens invited friends and family to join The Honorary Oysterville Militia (THOM) and gave them the opportunity to purchase commissions. He raised enough money to buy a replica 1841 Mountain Howitzer as a replacement for the historic cannon of village folklore. As general of the current-day militia, Stevens rallies his troops to fire the cannon for patriotic events, festive occasions, or just for the fun of it. He is quick to point out that only blank charges are fired. (Both, Sydney Stevens photographs.)

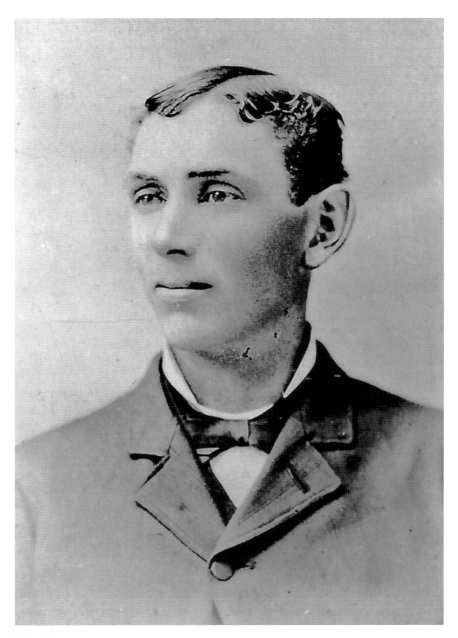

John "J.A." Morehead

John "J.A." Morehead did a number of remarkable things in his long life of community service. He was an early stagecoach driver, carrying mail from Ilwaco to Oysterville along the treacherous ocean beach. He was county commissioner at the time a group known as the "South Bend Raiders" kidnapped the county seat and moved it from Oysterville to South Bend. He established one of the first mercantile stores in Oysterville, relocated it to Nahcotta in 1889, and opened a branch in Ocean Park (the forerunner to current-day Jack's Country Store). He also bought the defunct town of Sealand, adjacent to Nahcotta, where he established Morehead Park, his proudest accomplishment. Bequeathed to the county by his family, the park continues to host thousands of visitors each year, especially 4-H and Scout groups, fulfilling Morehead's lifelong dream. (Dorothy Trondsen Williams Collection.)

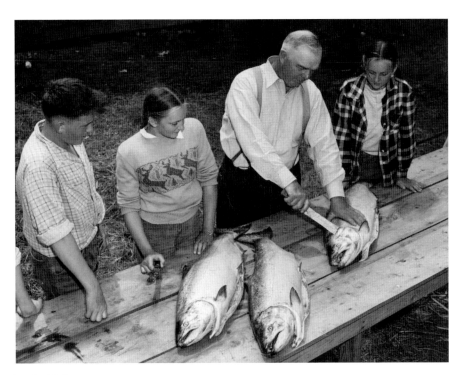

Charles A. Nelson

Charles "Charlie" A. Nelson, born in 1883, was fond of telling how he grew up in Oysterville with both white and Indian boys. He worked on Columbia River steamboats, was a fireman for the Ilwaco Railroad, picked native oysters on Willapa Bay, and owned a cranberry bog. He was greatly interested in regional history and enjoyed sharing native customs and local lore with young people. (Pacific County 4-H photograph.)

Anna Brooks

Anna Brooks taught in Oysterville from 1915 to 1918 and at Nahcotta School (pictured here) until her death in 1924. Both communities considered her the best teacher they ever had. Little information remains about her life except that she had a beautiful soprano singing voice, that her 10-year-old son Philip drowned in a tragic accident in 1912, and that her remaining son was institutionalized.

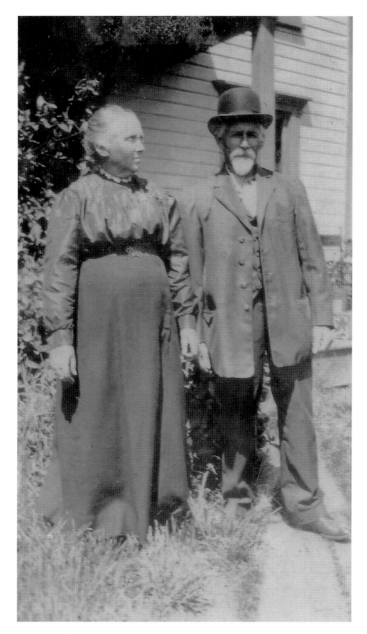

Laurine and Heinrich Wiegardt

Danish immigrant Heinrich Wiegardt ran away to sea as a boy; sailed the world; and, in the 1870s, came to Oysterville to work for the Morgan Oyster Company. He saved his money, moved across the bay to Bruceport, and started oystering for himself. Soon, he began courting Laurine Lauritzen, also from Denmark, who was nursemaid to the Cape Disappointment lighthouse keeper's children. By the third visit, Wiegardt wearied of the 30-mile trek to see his sweetheart, so he proposed, and they were married. It was Heinrich who began the family duck-hunting tradition. When the ducks flew over the bay in front of his house, he would open the kitchen window and shoot enough for dinner. In the 1890s, the Wiegardts moved to Ocean Park and built the house that is now their great-grandson Eric's (see page 68) watercolor gallery. (DWC.)

Eric Wiegardt

When lifelong Peninsula resident Eric Wiegardt received the highest national honor for a watercolor, one of the judges remarked that his finest achievement was not the prestigious American Watercolor Society's gold medal but the fact that he had managed to support his family and put four children through college as a full-time watercolorist. Wiegardt was especially pleased because his submitted painting *Duck Hunter* is of his father, Dobby Wiegardt (see page 69). The painting was subsequently used on the cover of the American Watercolor Society's 2012 catalog. It was a first for the publication, which had heretofore featured a text-only cover. (Left, Alan Kraft photograph; below, Sydney Stevens photograph.)

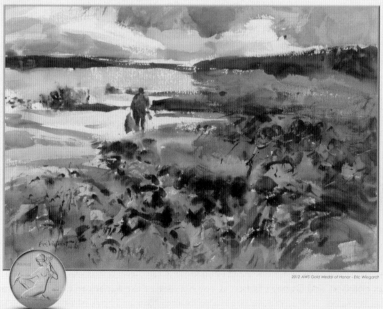

2012 AWS Gold Medal of Honor - Eric Wiegardt

American Watercolor Society

One Hundred Forty-Fifth International Exhibition - 2012

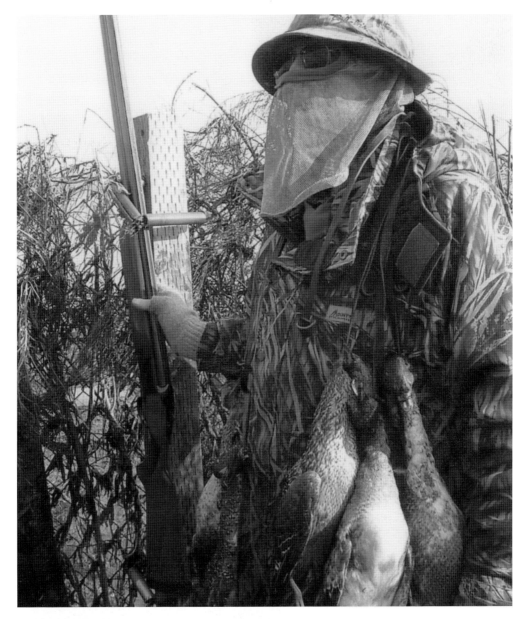

Dobby Wiegardt
Dobby Wiegardt is a third-generation Peninsula resident, oysterman, and duck hunter. One of his earliest duck-hunting memories is of spending the day at Leadbetter Point with his father and coming home to find that the entire community had been looking for them. It was December 7, 1941, the day Pearl Harbor was bombed, and Dobby's father, as commander of the American Legion, was needed. Within a day or two, his father had organized the Home Guard. Men and boys of all ages, including 10-year-old Dobby, practiced close order drills in the Ocean Park School gymnasium. He still has the Winchester .22 rifle that he carried at that time. Now, retired after a successful career in the family's oyster business, Dobby continues to be an avid duck hunter. He has taught his sons and grandsons to hunt, and each year he refurbishes the blind he built on the bay shore in front of his house—the blind he is headed toward in his son Eric's prize-winning painting *Duck Hunter*. (Marc Miller photograph.)

Ira and Jeff Murakami

Jeff Murakami and his second uncle Ira Murakami came to the Peninsula from their native Japan in 1917. They went to work in the cranberry bogs and on the oyster beds and, in 1929, brought the first Japanese oyster seed to the Northwest and to Willapa Bay—seed that was instrumental in reviving the failing oyster industry. Their lives were severely disrupted when, in early 1942, they and 110,000 other Japanese Americans were sent to inland relocation centers, then on to concentration camps, where they remained for the duration of World War II. Ira lost his cranberry bog and, at the war's conclusion, Jeff sold his share in the Eagle Oyster Packing Company of Nahcotta (below), though he continued working in the oyster industry for another 30 years.

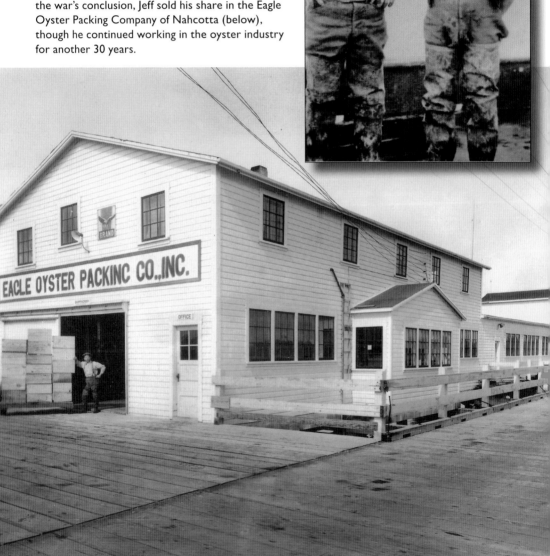

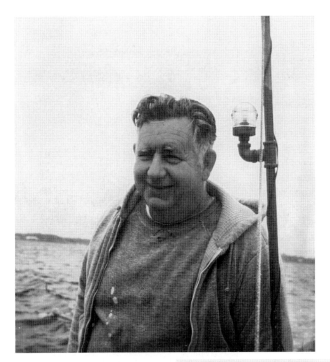

Les Wilson
When his father died, Les Wilson quit eighth grade and went to work to support the family. At 18, he was a brakeman for the local railroad, working in the oysters in his free time. He established the Wilson Oyster Company; managed the family farm; and, with his wife, Lucille, began the Ark Restaurant on the Nahcotta dock. Wilson Field in Nahcotta is named for him. (EFC)

Dick Sheldon
Oysterman Dick Sheldon prides himself on having spent more than 50 years protecting the water quality of Willapa Bay, especially as it is impacted by shoreline development in Pacific County. Among shellfish growers, he has been a leader in promoting strong environmental policies, although community members—from county officials to fellow oyster growers—do not always agree with his outspoken beliefs or his aggressive methods. (WBO.)

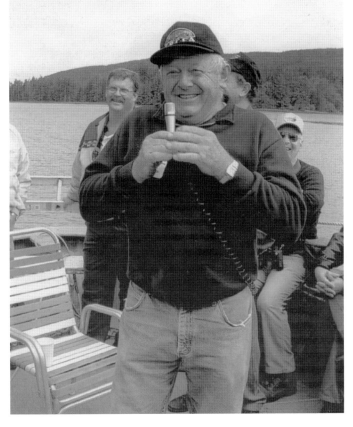

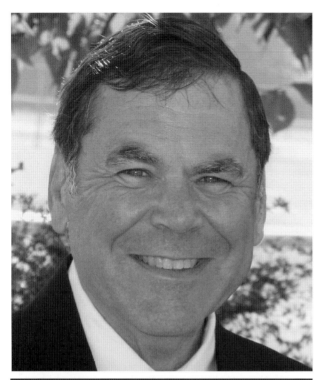

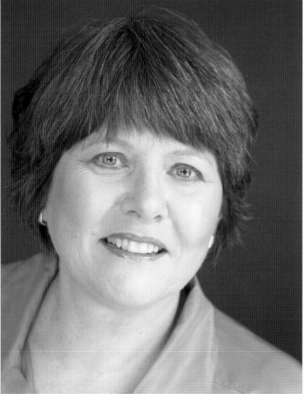

Frank Wolfe and Kathleen Sayce

Husband and wife Frank Wolfe and Kathleen Sayce have many diverse interests that focus on the Peninsula, Pacific County, and beyond. As both a ham radio operator and a firefighter/EMT, Wolfe has played a pivotal role in safety management over the years and is reassuringly knowledgeable concerning tsunami preparedness along the vulnerable Peninsula shoreline. He has recently been elected to the Pacific County Board of Commissioners. Sayce, a botanist and ecologist, has worked most recently in the field of assessments and operations efficiency for Ilwaco's Shorebank Pacific, the first environmental bank in the United States. She is a consultant for public and private entities on wetlands issues and, in her spare time, writes serious nonfiction articles and books on ecological matters and not-so-serious murder mysteries. (Top, Wolfe Photograph Collection; bottom, Amy Harrington photograph.)

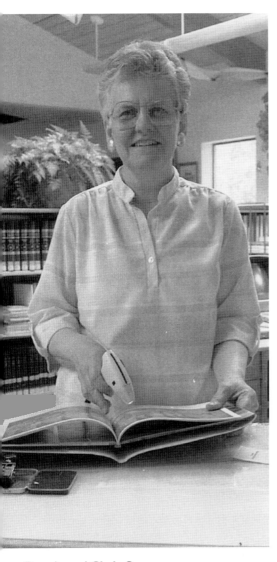 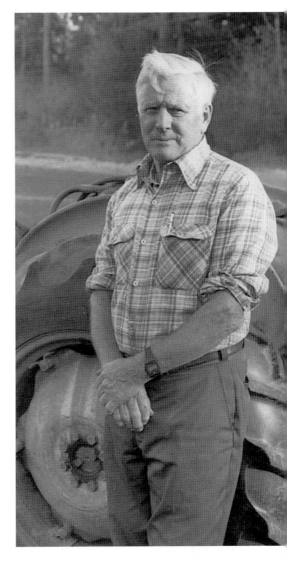

Bonnie and Clyde Sayce
Bonnie and Clyde Sayce arrived on the Peninsula in 1955 when Clyde accepted a position as fisheries biologist at the Nahcotta Field Station. Soon, he was on the school board, and instrumental in the formation of the consolidated Ocean Beach School District. Bonnie volunteered at the tiny Ocean Park Library. When the five-county Timberland Library District was formed, Bonnie became head librarian in Ocean Park, overseeing its years of growing pains and its eventual establishment in a fine new building near Ocean Park School. Meanwhile, the Sayces owned and operated a small cranberry bog, were leaders in the local Sandpipers square-dance group, and raised a family of three. The names "Bonnie and Clyde" have special meaning on the Long Beach Peninsula.

Margaret Russell
Margaret and Theo Russell built Nahcotta's Moby Dick Hotel in 1929. During World War II, it served as headquarters for the men and horses of the Coast Guard Beach Patrol. In 1948, a night at the Moby Dick was awarded by the popular radio show *Queen for a Day*. In the 1950s, Margaret gained notoriety for taming three raccoons—Shadrach, Meshach, and Abednego—and giving them an upstairs bedroom. (WFC.)

Dorothy Elliott
Dorothy Elliott opened Camp Willapa on the shores of Willapa Bay in 1918. It was the first privately operated summer camp for girls in the Northwest and would be in continuous operation every summer for the next 40 years. In 1926, she added Sherwood Forest for boys. She retired in 1957, selling her camps to the Alan Greiner family, which still owns the facility.

Ray Stone

It was difficult to tell whether Ray Stone promoted himself or Nahcotta more rigorously. In 1966, he ran for the fictitious position of mayor of the unincorporated bayside community, to the delight of the local media. He also served as president of the Shoalwater Bay Oyster Workers' Union, was a school board member, and, in 1948, assisted Dr. Trevor Kincaid (see page 56) at the State Oyster Lab in Nahcotta.

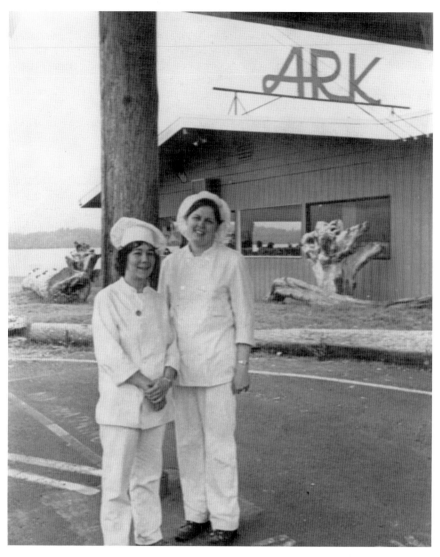

Jimella Lucas and Nanci Main

In the annals of Northwest cuisine, Jimella Lucas and Nanci Main are considered role models by several generations of chefs and the "best cooks ever" by their thousands of loyal patrons. Their suppliers and vendors know them to have stringent expectations for high-quality products. For more than 25 years, they enjoyed a national following at their Ark Restaurant & Bakery overlooking Willapa Bay in Nahcotta. "Where else," they said in their first Ark cookbook (1983), "outside our locale can you find Willapa Bay Oysters, Oregon Blue Cheese, Oregon strawberries, Washington wild blackberries, Oregon Veal, Columbia River salmon and sturgeon? We have them all; we serve them fresh. And we want you to look out our windows and see the sources of our bounty." They were among the leaders of the crusade for clean water in the region; introduced hundreds of local children to the wonders of growing, cooking, and eating their own food; and helped start Share Our Strength, a national organization working to end childhood hunger in the United States. Though they planned to retire after selling the Ark in 2003, they were back in the food business within a few years due to popular demand and their own seemingly endless supply of "restaurant energy." It's all happening again, this time in Klipsan Beach at Jimella & Nanci's Market Café. (Nanci Main Collection.)

Jayne Bailey

When Bailey's Bakery & Café opened in Nahcotta in 2006, proprietor and chef Jayne Bailey said it was exactly where she had always wanted to be. A food fixture of the Peninsula, she has worked in venues from Seaview to Ocean Park, has taught dozens of cooking classes, and has catered meals for banquets and birthdays. For a time, she provided once-a-week dinners to a group of pay-on-your-honor subscribers, leaving her garage unlocked so they could come pick up their jugs of homemade soup and loaves of freshly baked bread. Her customers include regulars from as far away as Seattle and Portland. They come for her scones ("best in the Northwest") and for her Sunday-morning-only thunderbuns ("get there early"), as well as for her other baked goods, her soups, and her made-to-order deli-style sandwiches. (Sydney Stevens photograph.)

The Macks

Wolfgang (left) and Günter (right) Mack, are brothers who married sisters—Wolfgang to Christl (left) and Günter to Andrea (right). They came to the Peninsula from their native Germany in 1978, the brothers going to work with their stepfather, a master carpenter and builder, and the sisters joining their mother-in-law in learning how to raise farm animals, grow food, and cook from scratch—a conscious choice for all three city-bred women. They built a communal house and a large workshop on wooded acreage south of Nahcotta. Each couple has three children, all of whom are used to explaining to people whether they are siblings or double cousins, and most of whom were homeschooled during their elementary years. Both couples have been active in community affairs since first arriving in this country, and the well-respected Mack Brothers & Sons Construction Company is often booked several years in advance. (Nani Mack photograph.)

Alan Housel "Pete" Hanner (OPPOSITE PAGE)

At age 97, Alan Housel "Pete" Hanner still has a clear tenor singing voice, gracing many Peninsula occasions with song—sometimes spontaneously, sometimes by request, and always to the delight of his audiences. It was through music that he courted and won his wife, Martha, in the 1930s. He hired a truck, found a guitar-playing friend, and serenaded her with "Stardust" under her Chi Omega sorority window. They married in 1937, and over the next 74 years (until her death in 2012), Pete continued expressing his love for Martha in song. During their first years of marriage, Pete was both lead singer and the baritone sax man with Duke Daley and His Orchestra, and the Hanners traveled all over the United States, playing in resorts and concert halls and living in one hotel room after another. By 1940, Hanner was using the stage name "Alan Lane" and was a featured singer ("They called me a crooner," he says.) with the Phil Hale Orchestra, playing in ballrooms and theaters up and down the West Coast. He later had his own radio show at KMPC in Beverly Hills and remembers clearly when the broadcast was interrupted on December 7, 1941, with the announcement that Pearl Harbor had been bombed. His show business days ended in 1946 when he came back from the war and joined General Motors. The job gave him a schedule more conducive to family life and also allowed the Hanners and their two teenaged children to travel extensively. These days, Pete lives in Nahcotta, just up the street from his daughter and son-in-law. He regularly attends tai chi classes at the Peninsula Senior Activities Center located in Klipsan Beach and participates fully in Peninsula activities, especially if there is music involved. (Hanner Family Collection.)

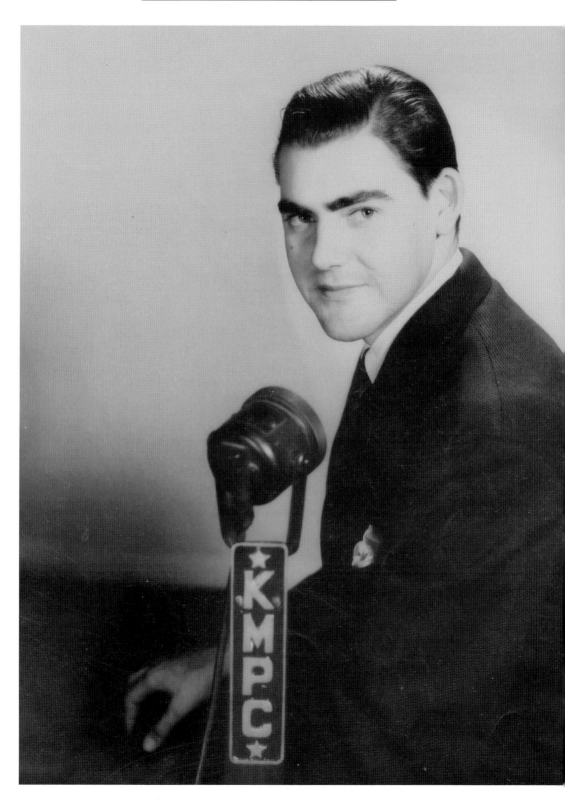

Verna Smith Oller

Verna Smith Oller was born just north of Long Beach at the northwest corner of Cranberry Road and the old narrow-gauge railroad line. She remembered having one pair of shoes. "They were high topped with buttons. We had to use a buttonhook to put them on. Now that's something you don't see anymore! I remember rolling back the soles on our shoes and putting pasteboard inside to make them last longer. We wore shoes when we went to school and to church and then we had to wear long stockings, too. I much preferred going barefoot and bare legged." From the time she could add to the family coffers, she worked. She picked cranberries, shucked oysters, shook crab, and waitressed—and was above all, frugal. When she married in 1931, she and her husband built a small house at a cost of $700.65. She lived there for the next 65 years and continued to work until about a year before her death, when she decided it was time to relax. She checked herself into an assisted living facility and paid for her care in advance. When she died a year later, Peninsula residents were amazed to learn that she had left $4.5 million earmarked for a community swimming pool in Long Beach. (Sydney Stevens photograph.)

CHAPTER THREE

Among the Dunes of the Pacific

It was not until 1889, when the narrow-gauge railroad linked the Peninsula's north-end settlements with those to the south, that the fledgling communities along the Pacific Ocean began to develop in earnest. At last, there was access to the thick forests and boggy bottomlands that lay between bay and ocean. Railroad and real estate promoters mounted lively campaigns to encourage summer tourism to "the longest beach in the world."

To the south was Long Beach. Begun in 1880 as a tent city called "Tinkerville," it promised seaside delights for vacationing families from the hot inland regions upriver. In 1886, the development of nearby Seaview began with advertising campaigns directed to affluent Portland families. The stylish, Carpenter Gothic "beach cottages" that sprang up often included a detached carriage house and a barn for horses and the family cow.

Ocean Park, located 10 miles north of Long Beach, began in 1883 as the Ocean Park Camp Meeting Association of the Portland Methodist Episcopal Church, with lots being sold only to members. Deeds forbade the use and manufacture of intoxicating drinks and other "immoral practices." Gradually, nonmembers bought into the community, summer cabins were built, and rules were relaxed. Today, Ocean Park is one of the fastest-growing areas in Pacific County.

Even though Peninsula development has escalated until boundaries between towns have blurred, residents tenaciously hold on to early traditions. Long Beach promotes its festivals, carnival rides, souvenir shops, and proximity to the beach. As a primary resort destination in the Northwest, its tourist-generated dollars are crucial to Peninsula economy. Seaview, long a haven for artists and writers, struggles to maintain its quiet residential atmosphere. Escalating weekend property rentals and uncertainties caused by accreting sand dunes generate subtle but relentless changes in the community dynamic and are an ongoing concern.

Ocean Park, with its grocery stores, library, bank, restaurants, lumberyard, shops, and galleries, has become the commercial center of the Peninsula's north-end. Rapid population growth strains the infrastructure, and residents try to sort out how to keep the old and accept the new with equanimity and goodwill.

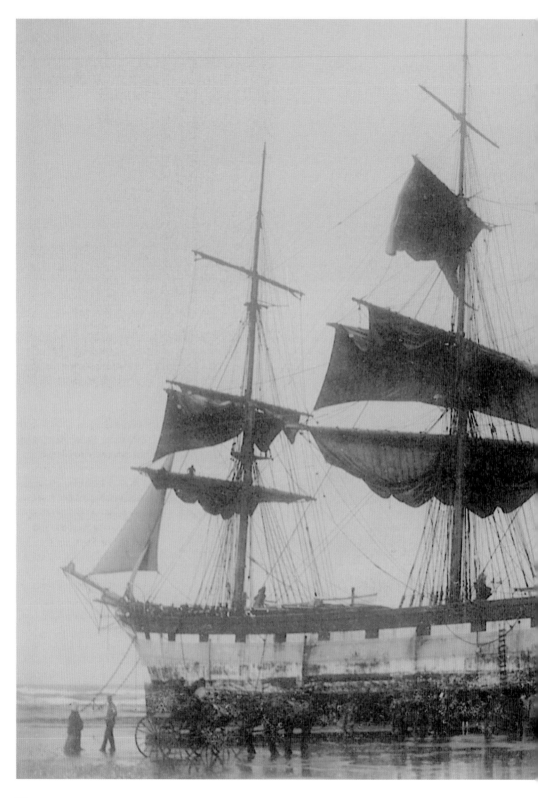

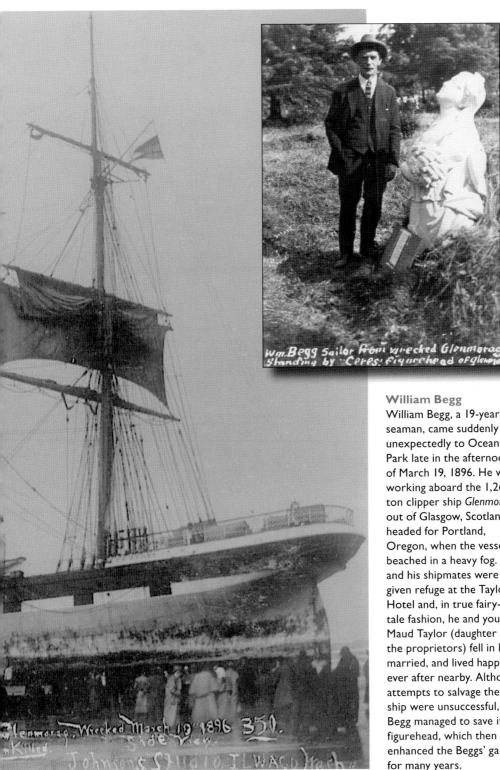

Wm. Begg Sailor from wrecked Glenmorag Standing by "Ceres" figurehead of glenmo

Glenmorag, Wrecked March 19 1896 350. Side View. n Killed. Johnsons Studio ILWACO Wach

William Begg

William Begg, a 19-year-old seaman, came suddenly and unexpectedly to Ocean Park late in the afternoon of March 19, 1896. He was working aboard the 1,267-ton clipper ship *Glenmorag* out of Glasgow, Scotland, headed for Portland, Oregon, when the vessel beached in a heavy fog. Begg and his shipmates were given refuge at the Taylor Hotel and, in true fairy-tale fashion, he and young Maud Taylor (daughter of the proprietors) fell in love, married, and lived happily ever after nearby. Although attempts to salvage the ship were unsuccessful, Begg managed to save its figurehead, which then enhanced the Beggs' garden for many years.

83

Adelaide Stuart Taylor
Daughter of a Quinault mother and a white father at a time when such parentage was not considered politically correct, petite Adelaide Stuart Taylor did not let that, or anything else, stand in her way. She was a respected midwife for the village of Oysterville; bore nine children of her own; and, with her husband, William Taylor, built the Taylor Hotel in Ocean Park. During the years that she owned and operated the hotel (1887 to the mid-1930s), the building often served important community functions, from providing housing for shipwrecked sailors to hosting fundraising activities for local and regional projects. The first streetlights in Ocean Park were financed largely through proceeds from card parties held at the Taylor Hotel, where "admission was 50 cents per person, 75 cents per couple; refreshments included." (Begg family photograph.)

Cyndy Hayward
Seattle attorney Cyndy Hayward arrived on the Peninsula in 2000 with the express purpose of establishing a residency program for artists. Her foundation, Willapa Bay AIR (Artists in Residence) launched in 2012. During the years between, Cyndy restored Ocean Park's historic Taylor Hotel, where she opened Adelaide's Books & Coffee, an immediate success as the premier gathering place of the Peninsula's north-end. (Gerald Bartlett photograph.)

Charles Fitzpatrick
Charles Fitzpatrick, "a skinny little bachelor," moved to Ocean Park in the early 1930s and for the next decade he photographed and sketched whatever caught his eye. Much of the visual documentation of the Peninsula is due to Fitzpatrick's interest in everything—shipwrecks, buildings old and new, men and women working. When he married, he gave up photography and moved away, leaving behind a legacy of historical images.

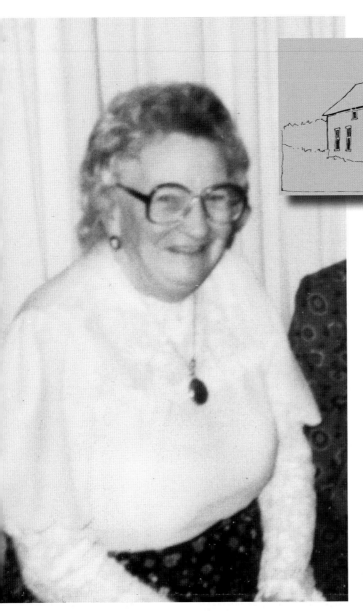

"WHALEBONE HOUSE."
Bay and Broadway, Ocean Park

Louise Rice

Shortly after Louise and Roy Rice moved to Ocean Park in 1952, Roy found a whale skeleton on the beach and placed it in front of their home (the original S.A. Matthews house). Since that time, it has been known as the "Whalebone House." Louise oversaw the structure's restoration and placement in the Washington State Register of Historic Places, then taught classes there in old-fashioned homemaking, based on her book *Soapsuds to Sunday School.* (Inset, Nancy Lloyd drawing.)

Stephen Adelbert "S.A." Matthews (OPPOSITE PAGE)

Stephen Adelbert "S.A." Matthews moved to the Peninsula from his native Maine in 1888. He designed and built a two-story, 10-room frame house in Ocean Park and, in 1891, moved in with his wife and six children. The house is considered a fine example of vernacular architecture. He continued to follow a building career and, by the time of his death in 1934 at age 82, was said to have constructed more than half of the area's early beach cottages. Matthews was known for his excellent craftsmanship, his sense of humor, and for the imaginative names he gave his five sons: Sedgewick Adelbert, Valverd Etheridge, Zhetley Vesper, Threllwood Dean, and Thedford Leston. *The Old Mariner*, a portrait of Matthews by Charles Fitzpatrick (see page 85), is the symbol for the Pacific County Historical Society.

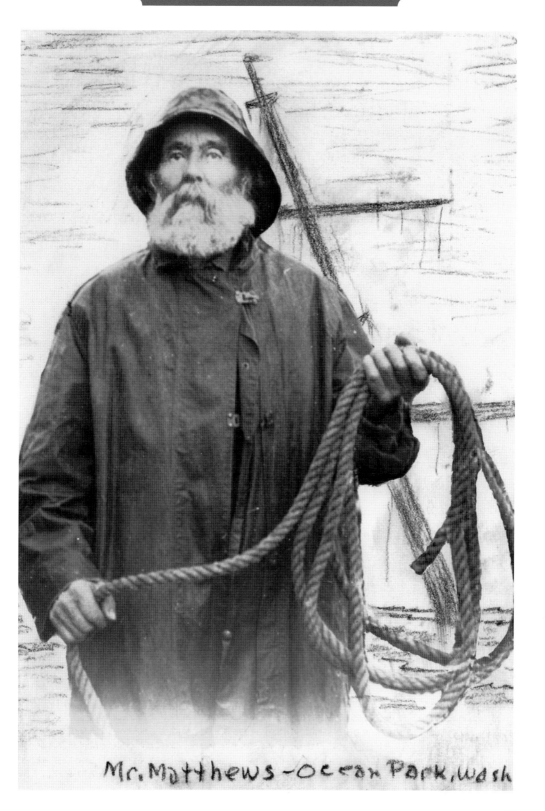

Mr. Matthews - Ocean Park, Wash

Guy Allison

Writer Guy Allison became famous on the West Coast in the 1930s for his syndicated column, "Bypaths of History." On the Peninsula, he became famous for "The Wreckage," his beach cabin in Ocean Park. It was built completely of lumber salvaged from two maritime accidents that occurred during the winter of 1911—one involving dozens of fir logs that washed onto the beach, and the other, a load of tongue-and-groove lumber. The only tools used in the building of the house were an axe, a saw, hatchet, screwdriver, froe, and a block and tackle. Among friends who helped with the construction was Zetley Matthews who, like his father, S.A. (see page 86), had a hand in building many of Ocean Park's homes and cabins. Allison completed the Wreckage with furniture fashioned from driftwood and placed fanciful driftwood animals around the property as yard art.

Harry Clair Jr.

Like most Ocean Park residents in the 1920s, Harry Clair Jr.'s family members were Portlanders who had a vacation place on the Peninsula. Clair spent his childhood summers at the beach and, during summers between terms at college, he went to work for the Ilwaco Railroad, first as a section hand (right), later as a fireman, and finally as a rear brakeman, "complete with uniform!" The Clair family still maintains their summer residence in Ocean Park.

Ocean Park Theatrical Group

Known as the "All Boy Players," the Ocean Park Theatrical Group performed in the hall above Trondsen & Peterson's Store in the late 1930s. Standing are, from left to right, Art Mack, Walt Chellis, Bill Summerfelt, Johnny Morehead, Sanford Slagle, Ed Chellis, Owen Yeager, Beverly Stevens, and Art Matthews. In front is Edgar Yeager.

Daniel James Crowley

Daniel James "Jim" Crowley came to the Peninsula in 1922 as director of the first Cranberry Research Station in Long Beach. For the next 54 years, he worked to eradicate the problems facing the cranberry farmers of coastal Washington and Oregon. In the early years, without a laboratory or a car, Crowley conducted his experiments in an old shed on his property and made his inspection tours from Ilwaco to Oysterville (a round-trip of 40 miles) by foot. His greatest contribution to horticulture was in the area of frost injury prevention, and his recommendations were based on what he was taught in physics concerning the release of heat from water during the freezing process. Growers were hard to convince, but, eventually, the sprinkler systems he suggested became standard equipment for commercial cranberry growers, as well as other fruit growers throughout the world.

Guy C. Myers

Guy C. Myers was an investment banker with headquarters on New York's Wall Street and at the Olympic Hotel in Seattle. In 1940, he bought land in the center of the Peninsula, ultimately accumulating 1,000 acres, 93 of which he put into cranberry bogs. He named his farm Cranguyma—"cran" was for cranberries; guy was for his own name; and the last three letters, "yma," were a reverse spelling of his wife's name, Amy. During the next several decades, he continued developing the farm to include blueberries, raspberries, and a nursery in which rhododendrons and azaleas were raised. A processing plant at the south end of the property produced a variety of cranberry products, including sauces, juices, cranberry-flavored sherbet, and more. Ten miles of railroad track were laid through the center of the farm for ease of access to the bogs. Meyers also introduced a number of exotic birds to the property, though now only several dozen peacocks remain. At its peak, Cranguyma Farms was the largest cranberry farm west of the Mississippi. Interestingly, Meyers never lived on the property or on the Peninsula. He was a frequent visitor, though, staying at the Breakers Hotel in Long Beach with his wife and other family members. His only daughter, Marguerite, and her husband, Frank Glenn Sr., purchased Cranguyma Farms in 1959. It is now owned and operated by Myers's grandson Frank Glenn Jr. and great-grandson Frank Glenn III. (Glenn family photograph.)

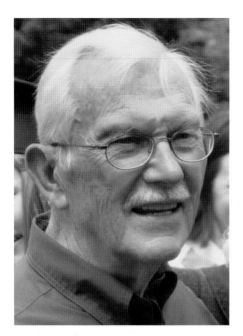

Russell Watterberg
Rev. Russell "Russ" Watterberg and his wife, Myrtle, began the Dunes Bible Camp in 1957 under the auspices of the Southwest Washington Conservative Baptist Association. Their goal was to provide fun and Christian education to boys and girls. Now, more than 50 years later, the Dunes Bible Camp provides facilities for Christian groups of all ages, all year long. The Watterberg family continues to oversee its operation. (Watterberg family photograph.)

Birdie Etchison
Birdie Etchison is a mother of five, grandmother of eight, and great-grandmother of ten. For 60 years, she has made her living by writing, both fiction and nonfiction. She has written for newspapers, magazines, and devotional journals, and has 21 published book titles to her credit thus far. Additionally, she finds time to participate in writers' groups and conferences, and she often conducts classes for budding authors. (Gail Denham photograph.)

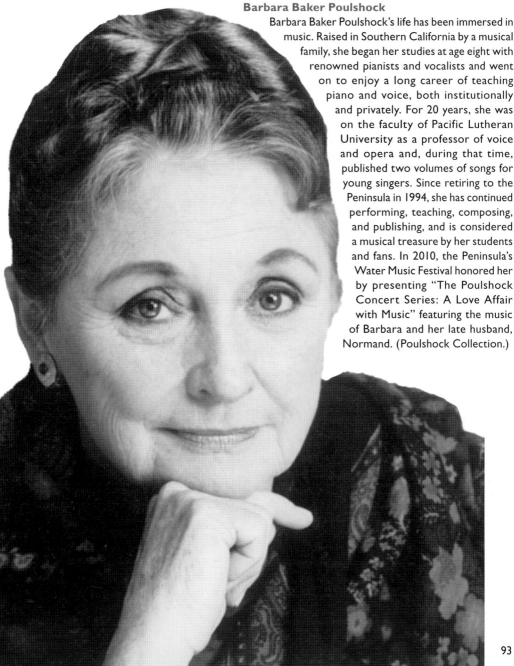

Barbara Baker Poulshock
Barbara Baker Poulshock's life has been immersed in music. Raised in Southern California by a musical family, she began her studies at age eight with renowned pianists and vocalists and went on to enjoy a long career of teaching piano and voice, both institutionally and privately. For 20 years, she was on the faculty of Pacific Lutheran University as a professor of voice and opera and, during that time, published two volumes of songs for young singers. Since retiring to the Peninsula in 1994, she has continued performing, teaching, composing, and publishing, and is considered a musical treasure by her students and fans. In 2010, the Peninsula's Water Music Festival honored her by presenting "The Poulshock Concert Series: A Love Affair with Music" featuring the music of Barbara and her late husband, Normand. (Poulshock Collection.)

Lucille and Jack Downer

Lucille and Jack Downer opened Jack's Country Store shortly after they arrived on the Peninsula in the 1960s. It was the fourth incarnation of Trondsen & Peterson's on the corner of Bay and Vernon in Ocean Park—the store that had begun a century before as Morehead's Mercantile in Oysterville. Lucille managed the front end of the store, which included groceries and housewares, with a firm hand and an eagle eye. Jack managed the hardware end of things, and many of his customers considered him their electrician, plumber, gardener, and master of all trades. He suggested solutions to every fix-it problem imaginable, patiently explaining various options and gladly exchanging purchases if his suggestions were not workable by his amateur "apprentices." Jack picked up litter and swept the parking lot every morning before opening the store and gathered up stray shopping carts each night before closing. He served on the school board; supported the Friends of Lewis and Clark; was the impetus behind saving the Chinook School and Gym; and gave generously, but always anonymously, to those in need. Lucille, too, was a hands-on proprietor, serving her shift at the cash register well into her eighties and often working overtime so that Jack could participate in community projects. She also wrote a cooking column for the local newspaper, and while Jack focused his energies on the community, Lucille's outside-of-work interests revolved around her family. Jack's Country Store, said to be the West Coast equivalent of the Vermont Country Store, is now operated by second- and third-generation Downers. On the Peninsula, locals pay scant attention to the store's disclaimer, "Contrary to public opinion, we do not have everything." (Above, Downer Family Collection; inset, Sydney Stevens photograph.)

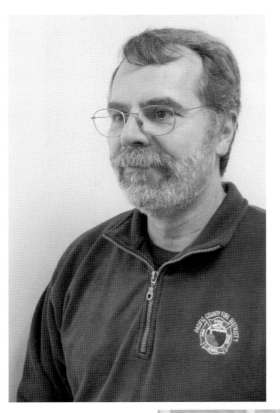

Steve Bellinger
One thing led to another when Steve Bellinger became a volunteer fireman for Pacific County Fire District No. 1 in 1983, and soon he was taking classes to become an EMT (emergency medical technician). With that goal accomplished, he continued school, becoming a paramedic and then a physician's assistant. Though a staff member of Ocean Beach Medical Clinic since 1999, he continues his volunteer work in his off hours. (Jeanne Bellinger photograph.)

Doug Knutzen
Doug Knutzen became involved in water rescue while serving at the US Coast Guard Station Cape Disappointment. Since his honorable discharge in 1980, he has gained wide recognition as an expert at both rope and Jet Ski rescue. He is president of Pacific County Technical Rescue, battalion chief of Pacific County Fire District No. 1, and is the owner of Box K Auto Repair in Seaview. (Shawn Alladio photograph.)

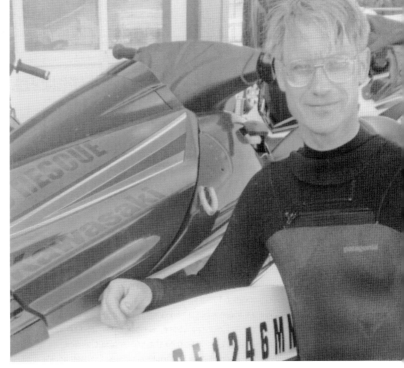

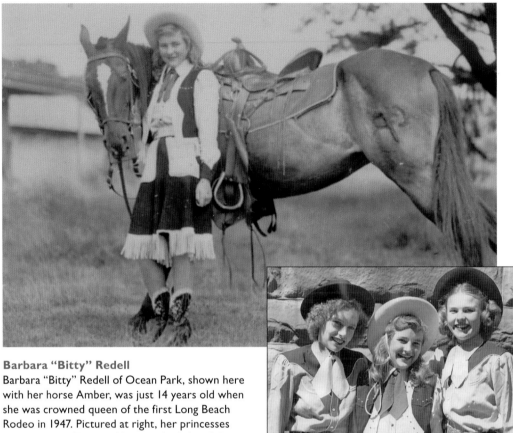

Barbara "Bitty" Redell

Barbara "Bitty" Redell of Ocean Park, shown here with her horse Amber, was just 14 years old when she was crowned queen of the first Long Beach Rodeo in 1947. Pictured at right, her princesses were Dorothy Taylor of Seaview (right) and Gerri Maki of Nahcotta (left). The annual rodeo is a continuing tradition on the Long Beach Peninsula. (Both, Ann Anderson Photograph Collection.)

Loren Corder

Loren Corder owned an automobile dealership in Vancouver, Washington, as well as acreage on the Peninsula. To maximize his vacation time, he bought an airplane and built a landing strip near his Klipsan home, where he eventually retired. His 22 acres were left in trust for the Peninsula's senior citizens. Golden Sands Assisted Living, the North Beach Family Clinic, and the Peninsula Senior Activities Center have since been built on the property. (Mikkola Collection.)

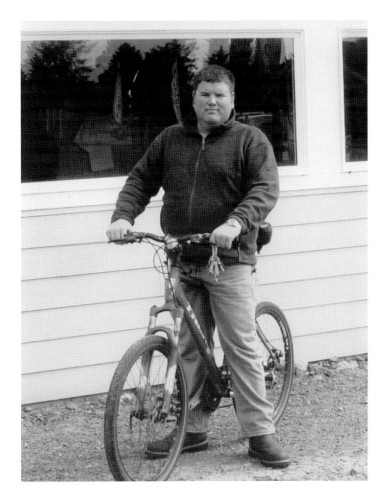

Otto Hill

When Otto Hill was diagnosed at Doernbecher Children's Hospital with high functioning autism, his family and the school district went to work to provide him with the best possible educational program. Otto made it easy for them. He was always sunny, positive, caring, and helpful, and he always tried his best. He was just 16 when a part-time Ocean Park neighbor gave Otto his house key and asked him to "keep an eye on things" until he returned to the beach from his home in Portland. Otto was diligent in his duties. Word of mouth spread, and nine years later, Otto had 102 customers whose homes he checks twice a week, year-round. That means that Otto has 102 unlabeled keys and knows the house and owner that go with each. He has divided the houses on his route into three sections and travels to each by bicycle, carefully checking for anything amiss. Should there be problems, such as damage caused by a winter storm, Otto knows which plumber or electrician to call, and more than once, has alerted the sheriff to a break-in or other questionable activity. For some customers, he turns the heat on a few hours before their expected arrival. He accompanies others on their walks, or visits with those who might be lonely. He has even introduced people he feels might like to know one another, and lasting friendships have been the result. Otto owns his own little house and has seven bicycles—only one favorite—but also a bike he won in a raffle, a bike that was a gift, and several that he will lend to people in need. He is a familiar figure in Ocean Park and Nahcotta and is often stopped by locals or visitors who have questions about the area. If Otto does not know the answer, he will find out before the day is over. He is widely known as "the mayor of Ocean Park." As his mother, Pam, says, "Otto is a gift to us. If everyone looked at the world through Otto's eyes it would be a much better place." (George Hill photograph.)

Henry Harrison Tinker

In 1880, Henry Harrison Tinker purchased one square mile of a sandy swamp along the 28-mile stretch of weather beach on the Pacific Ocean. His dream was to develop a resort that would attract visitors year-round. He laid out lots and blocks, reserved picnic areas, named streets, and began filling in the lowlands. For those who could not afford to buy one of the tent-sized lots, or those who were just passing through, he built the Long Beach Hotel. Called "Tinkerville" for many years, the development became hugely popular with Portland residents when the Ilwaco Railroad was built in 1889. Transportation by side-wheeler down the Columbia River and north by rail to the "long beach" led to the establishment of substantial vacation homes and resulted in the incorporation of the City of Long Beach in 1922.

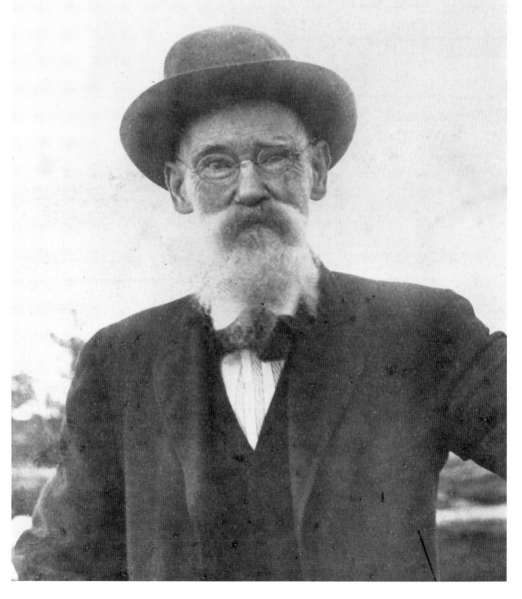

Ambrose Hager
Known to his family as "Uncle Bro," Ambrose Hager was a fireman on the Seattle, Portland & Spokane Railway before retiring to Long Beach in the 1920s. He bought a two-room cabin for $5 and moved it onto some family property, naming it "The Five Spot." He worked as a drayman, hauling luggage for vacationers, and was seldom seen without a deputy's badge and a pipe or cigar.

Lolita Tinker Morris
Lolita Tinker Morris lived to be 102 years old. Throughout her life, she was proud of her family and of their accomplishments. Her grandfather had founded Long Beach, and when the town was incorporated years later, her father became its first mayor. But what delighted her most in later life were her great-grandchildren, the Shier quintuplets, shown here with Lolita at her 100th birthday celebration.

Ray Millner

Ray Millner was teaching at Ilwaco High School and working as a janitor on the side when his doctor advised a change. He put his energy into his love of gardening, built a greenhouse for his wife, and encouraged the kids to participate, as well. The resulting business, The Planter Box, was the first full-service nursery on the Peninsula and is still a generational family operation. (Right, Millner Family Collection; below, Sydney Stevens photograph.)

Elizabeth Lambert Wood

Elizabeth Lambert Wood's 1894 wedding present, a three-story beach cottage with distinctive widow's walk (below), served as a staging area for her philanthropic activities, which were especially directed toward the children of Long Beach. Though she lost her husband and two children, one by one, in tragic circumstances, she maintained a positive attitude as author of juvenile books about pioneer times in the West and Northwest. (Both, Candy Glenn Collection.)

Betty Paxton
When the banners went up at Astoria's Safeway store in August 2012, they were in honor of birthday girl Betty Paxton, who was turning 98. At that time, she was the oldest employee in all 1,743 stores of the Safeway chain. As a "bag girl," she carries out groceries, gathers up shopping carts, and picks up litter. Betty lives in Long Beach and commutes across the Astoria/Megler Bridge each workday. She loves her job and says she especially enjoys offering to carry groceries for people she knows are "only" in their seventies or eighties. "It keeps me feeling young," she says. She attributes her energy and good health to an active life, with "lots of skiing and hiking and camping when I was young." (Sydney Stevens photograph.)

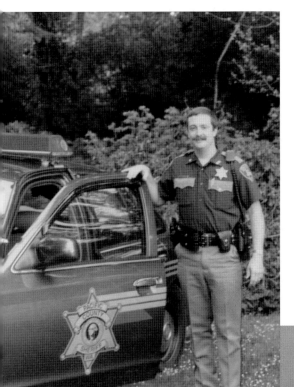

Kendall Biggs

During the summer of 1985, following his junior year at Ilwaco High School, Kendall Biggs was sponsored by the local Kiwanis Club to attend its statewide Youth Law Enforcement Career Camp. From then on, this fourth-generation Peninsula resident followed an educational path toward law enforcement. Now a Pacific County Deputy Sheriff, Biggs lives with his family in Long Beach. (Darlene Biggs photograph.)

Donald Cox

Young pharmacist Donald "Don" Cox came from Longview in 1950, buying into two existing pharmacies in Ilwaco and Long Beach. He soon hired two more pharmacists; expanded the business to include a branch in Ocean Park; and, later, opened pharmacies in South Bend and Raymond, all under the name Peninsula Pharmacies, Inc. When he retired in 2002 at 81, he had been in the pharmacy business for 55 years. His family continues the tradition. (WBO.)

Jean Tilden Nitzel
When Jean Tilden Nitzel's logger husband broke his ankle, he bought a photographic enlarger to pass the time. Jean was soon bringing him picture orders from the *Chinook Observer,* where she worked, and by 1981, their business had outgrown the space above their garage. The Picture Attic, specializing in photography, custom framing, and art supplies, continues to be a full-time occupation for them both. (Lynda Lane photograph.)

Keleigh Schwartz
Although her business has a physical presence in Long Beach, it is through cyberspace that Keleigh Schwartz's influence is felt worldwide. Beachdog.com began in 1997 and, according to Schwartz, took on "a life of its own." It now represents a diverse clientele, from writers and artists to nonprofit foundations and large business corporations. Its "one-stop marketing" services include web development, logo design, and every aspect between. (Robyn Unruh photograph.)

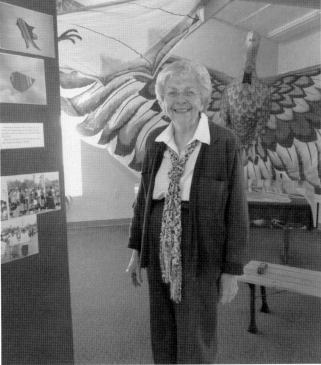

Jim and Kay Buesing
Jim Buesing's love affair with kites began in 1980 when his wife, Kay, gave him a two-string "Skyro Gyro" for Christmas. Within months, they had bought a small building on Long Beach's main street and opened a kite shop. Jim gave away as many kites as he sold, encouraging friends and strangers alike to "go fly a kite!" When the Washington State International Kite Festival began in 1981, the Buesings were soon in the thick of it, applying for grants and hosting kite flyers from all over the world. They even traveled to China in 1987 where they represented the United States at the Fourth Annual Weifang Kite Festival. They soon organized the World Kite Museum & Hall of Fame, and Kay, a retired teacher, became its director, devoting her full attention to "the only American Museum dedicated exclusively to the thrill, joy, art, science, and world history of kites." In 2003, Kay was inducted into the museum's Hall of Fame for "immeasurable contributions" to the kiting world. (Top, Buesing Family Collection; bottom, Sydney Stevens photograph.)

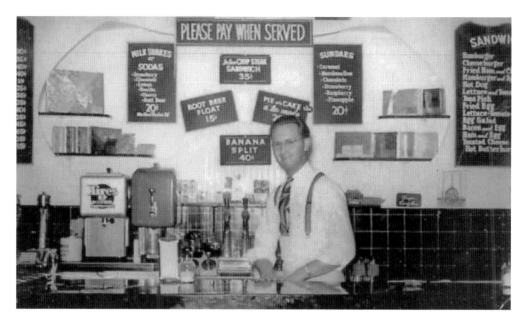

Red O'Connell

Red O'Connell arrived in 1939, opened Red's Sandwich Shop in Long Beach, and began actively promoting the area. He participated in statewide tours of the famed Largest Fry Pan in the World, assisted with the annual clam feed, served as chief of the Long Beach Fire Department, and helped establish the Long Beach Ambulance service. Locals still remember his 1950s-style restaurant in Ilwaco, Red's Restaurant & Flame Room.

Bob Andrew

Bob Andrew and his wife, Judi, are the Peninsula's "Mr. and Mrs. Patriotism." From the flags and "Support Our Troops" posters in their popular Long Beach establishment, the Cottage Bakery, to their years of leadership at the annual Loyalty Day festivities, they have continually demonstrated their devotion to flag and country. In addition to his baking duties, which usually begin at 1:00 a.m., Bob has served as mayor of Long Beach since 2002. (Andrew Family Collection.)

Mary Lou Mandel

A riveter at Boeing during World War II, Mary Lou Mandel moved to Long Beach in 1952 and went into the tavern business. Her establishment, Mary Lou's, was known for its fabulous meals, its zany Halloween parties, but mostly for its warm and generous proprietor. She had big black hair and a whiskey voice, called every woman customer "Dolly," and gave each man a not-so-flattering nickname. Her work uniform included a food-stained top, hot pants, and white go-go boots. Mandel donated "a truck's worth" to the fire department, cheered enthusiastically for the University of Washington Huskies, and rode on a custom-built float in the annual Loyalty Day Parade. When not working, she was well-dressed, shy, soft-spoken, and usually the center of attention. She is remembered as a "Peninsula institution." (Donella Lucero Collection.)

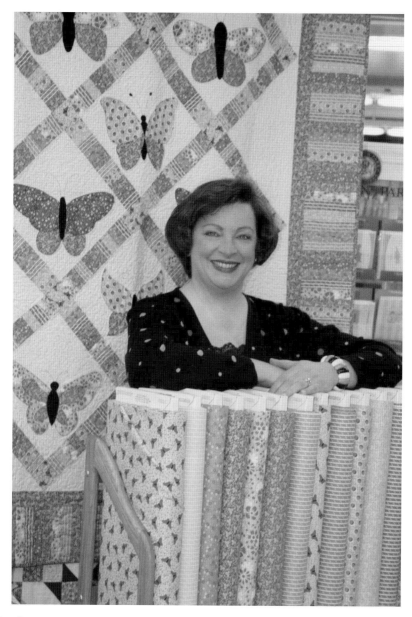

Karen Snyder

On the Peninsula, the names Karen Snyder and Anna Lena are all but synonymous. Anna Lena is the name of Snyder's business, chosen in memory of her great-grandmother. Under the Anna Lena label, Snyder first developed a line of cranberry products, then opened Anna Lena's gift shop and, as she developed a personal interest in quilting, added a few bolts of quilt fabric to her inventory. Before long, she had 5,000 bolts, and her business had become the quilting center of the Peninsula and surrounding area. Next, she wrote a book, and, in 2006, her first fabric line came out. Now, with four books in print, she has retired from the shop-keeping business, although she continues to quilt and has become a top designer of quilt fabrics for a prestigious New York company. She specializes in 1930s Americana designs, many of which are inspired by fruitless fabric searches for her own projects. Snyder has lived and worked in Long Beach her entire life, with the exception of her college years. (Karen Snyder Collection.)

Sen. Sid Snyder

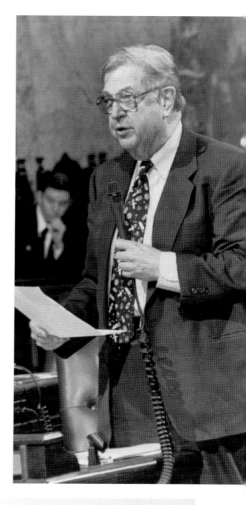

Sid Snyder's career at the state capitol spanned more than 50 years. He began in 1949 as an elevator operator, soon became a supervisor in the Bill Room, was eventually elected secretary of the Senate, and served 12 years as senator from the 19th District. In 1995, he was elected as the Senate Democrats' leader, a position he held for seven years, including five as majority leader. At the end of each session, he returned home to Long Beach, where he worked in his grocery store, Sid's Market, in nearby Seaview, and involved himself in community affairs, helping found the Bank of Pacific and investing in real estate. The son of a barber, he was a Democrat "born and raised" and was known as a moderately conservative party loyalist who was not afraid to compromise and collaborate with reasonable opponents. According to one story from his days as an elevator operator, he was giving a lift to two Republican lawmakers who asked young Snyder his party affiliation. He was a Democrat, Snyder explained, because his father was a Democrat, as was his grandfather. Questioning the young man's logic, one of the solons asked, "If they were horse thieves, would you be a horse thief?" Snyder allegedly responded, "No, I'd be a Republican." He retired in 2002 to spend more time with his wife, Bette, and his children and grandchildren. The city fathers of both Long Beach and Olympia have named key thoroughfares Sid Snyder Drive, and at his funeral service in October 2012 (held in the Ilwaco High School gym, the Peninsula's largest venue), Washington governor Christine Gregoire said. "Washington State government has lost one of its giants. Sid was unique and irreplaceable . . . legendary for getting things done and for his never-failing courtesy and civility. He represented his district and the people of our state with principle, dignity, and modesty. They just don't come finer than Sid Snyder." (Right, Snyder family photograph; below, Sydney Stevens photograph.)

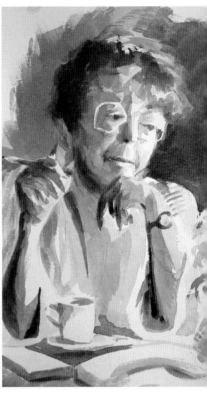

Val Campiche

As Val Campiche's children were approaching high school age, she decided to do something about Long Beach taxpayers' longtime "no library" decision. Her remedy was to rent a hole-in-the-wall storefront, drive her old station wagon to Seattle on a book-buying spree, and set up a lending library. Her husband, John (see page 28), made an ornate Booklender sign to hang above the door. The business was a wonderful success. When Val decided to morph the lending library into a full-service bookstore, she bought a building across the street, changed the "l" in her sign to a "v," and opened the Bookvender. When her funds finally allowed, she changed the "e" to an "o," and for the next 35 years, Bookvendor served the book buyers of the Peninsula and beyond. (Left, Campiche Family Collection; right, John Campiche watercolor.)

Gordon Schoewe and Roy Gustafson
When Gordon Schoewe (right) and Roy Gustafson (left) moved to Long Beach in 1972, they bought and rehabbed a fixer-upper motel, and later, a 15-room historic house. They served on boards of nonprofit organizations, worked in various capacities for county government or for local businesses, and eventually bought the Bookvendor from Val Campiche (see page 110). They gave the biggest and best parties and, in turn, were at the top of everyone's invitation list. Schoewe's 84 scrapbooks documenting their partnership and life at the beach are archived at the Columbia Pacific Heritage Museum. At age 86, he still faithfully visits his 106-year-old mother, who lives several hours distant from the Peninsula. (Kathy Egawa photograph.)

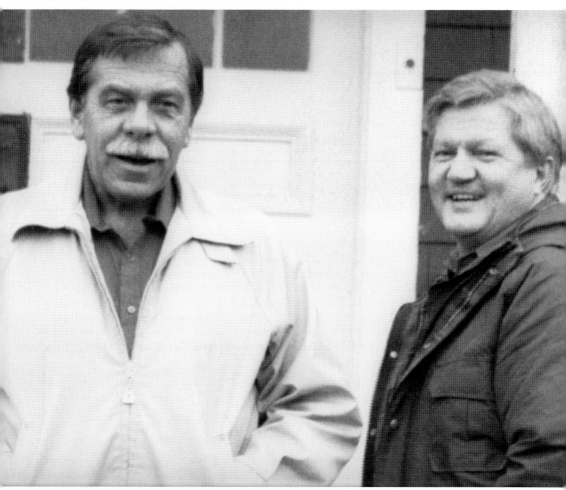

Elaine and Allen Goulter

Allen Goulter opened the first veterinary clinic to serve the Peninsula in 1952. His wife, Elaine, was veterinary receptionist, medical assistant, and kennel cleaner—his "Girl Friday," Dr. Goulter said. In 1977, the Goulters bought the old Sugarman's Grocery Store in Seaview, transforming it to the state-of-the-art Ocean Beach Animal Clinic. The Goulters also raised beef cattle on their Chinook ranch and were active Long Beach Boosters. (Goulter Family Collection.)

Ed and Catherine Ketel

Peninsula pet owners often mention the magic that occurs when visiting Ed and Catherine Ketel's Oceanside Animal Clinic. No matter how hurting or anxious pet or owner is, calm reassurance permeates the atmosphere. Since 1980, when they bought the clinic, the Ketels have dispensed TLC right along with their veterinary skills. Dr. Ed specializes in surgery and large animals and Dr. Catherine in medicines and small animals. (Sydney Stevens photograph.)

Lorrie Knudson Phelps
Some call her the "Tooth Nazi." Others swear she is the tooth fairy. From either perspective, Lorrie Knudson Phelps is known on the Peninsula as the most thorough, diligent, and dedicated dental hygienist of the region. She chose her career in the 1970s while still a student at Ilwaco High School, the result of a vocational education internship in Dr. William Walker's office. She continued her education, returned home to marry her high school sweetheart, and has since worked in a dozen or more dental offices. She has also volunteered her time in school dental health programs and has gained national recognition for helpfulness toward her hygienist peers. (Alina Carlson photograph.)

Wellington W. Marsh
Wellington W. Marsh came to the Long Beach Peninsula from his native North Dakota in 1926 and began seriously collecting curiosities. He opened the original Marsh's Café, marketed oysters on the side, and began his most lasting legacy: Marsh's Free Museum. He promoted his businesses with an enthusiasm reminiscent of old-time medicine showmen, even hosting clam fries outside his museum in the World's Largest Frying Pan (pictured here) and making incredible claims about the oddments in his collection. Although the business has expanded manyfold and has moved across the street from its first location, a "stop" at Marsh's Free Museum is still considered a must by most visitors to the Peninsula. (Both, Marsh Family Collection.)

Jake-the-Alligator-Man

A star attraction on the Peninsula is Jake-the-Alligator-Man. Purported to be half human, half alligator, and in mummified condition, Jake is on display at Marsh's Free Museum in Long Beach. The curiosity was purchased by Junior and Marian Marsh in 1951 from a California carnival man for $700. Since then, his faithful followers have reached cult-like proportions, dressing up in outlandish regalia for his Annual 75th Birthday Celebration and periodic weddings. It is rumored that nowadays, in his fragile condition, he depends upon a double ("Fake Jake") to make obligatory celebrity appearances. He is also known to appear unexpectedly at local birthday or cocktail parties, often dressed in his elegant red smoking jacket and escorted by one of many lady friends. (Above, Marsh Family Collection; below, Sydney Stevens photograph.)

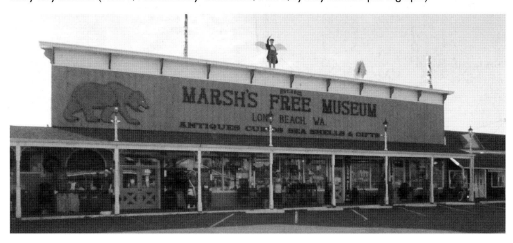

Charles Beaver
Ohio attorney Charles Beaver arrived on the Peninsula in 1890 and went into the contracting business. He built a number of the homes in the Seaview Cottages district, but is best-remembered for his Shelburne Hotel. In 1909, he and his wife sold it to Mr. and Mrs. W.C. Hoare, who moved it across the street and joined it to another building, enlarging it to its present size. (EFC.)

Julia Hoare Williams
Julia Hoare was 12 when her parents bought the Shelburne Hotel in Seaview and moved from Portland, Oregon, to manage it. After graduating from the University of Washington, she taught at Ilwaco High School and married Jack G. Williams, who often teased, "I took a Hoare and made her a lady!" She was a founder of the Mentor Study Club, which still meets twice monthly on the Peninsula.

Laurie Anderson and David Campiche
Laurie Anderson and David Campiche have the distinction of owning the oldest continuously operating hostelry in Washington State: the Shelburne Inn (below). Built in 1886 by Charles Beaver (see page 116), it retains its original ambience despite having been refurbished many times. Under the stewardship of Anderson and Campiche, it has been placed in the State and National Registers of Historic Places. (Right, Nancy Campiche photograph; below, Laurie Anderson photograph.)

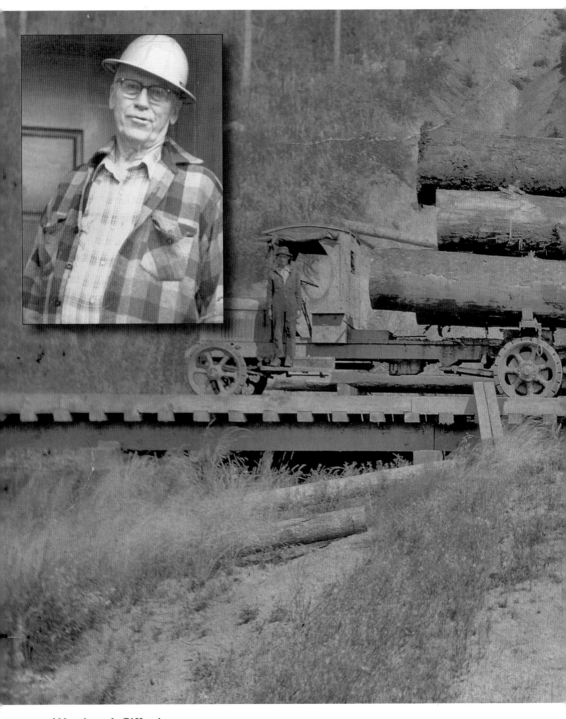

Woodrow J. Gifford

Woodrow "Woody" J. Gifford was a logger. He worked for the Weyerhaeuser Company, bucking and "doing a little bit of everything." It was as the celebrated "Logger Poet of Seaview," however, that he was best known. He began writing poetry in high school and continued to hone his skills over the years

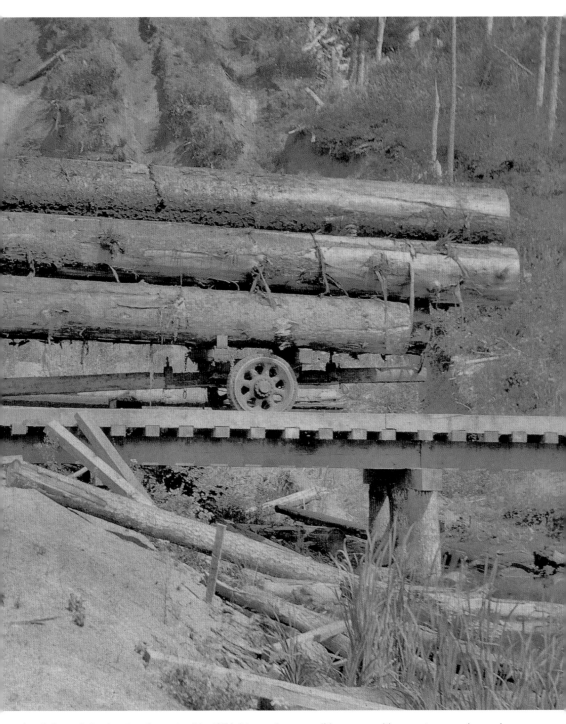

that followed. By the time he retired in 1974, his work was well known, and he was in great demand at folk festivals and celebrations throughout the northwest. Always a show-stopper was his poem that began: "Back in those Glory Days now past / To insulate from Winter's Blast, / Long-johns were worn by Loggin' Men / The first suit knit no one knows when."

Matt Winters
As both the editor and publisher of the Peninsula's only remaining newspaper, and the great-great-grandson of Washington Territory homesteaders, Matt Winters feels a particular responsibility regarding the changing needs of a dynamic community and the necessity of fostering historic preservation. In determining the *Chinook Observer*'s editorial direction, he is ever mindful of the stresses on traditional Peninsula industries and is acutely aware that success can bring its own set of problems—culturally, environmentally, and socially. "It's not my role to intervene, but to listen to the community," he says, "and perhaps give a gentle nudge now and then concerning our path to the future." His appreciation for history shapes each weekly issue of the 112-year-old newspaper, from his own editorial articles to the inclusion of history-minded columnists. Under his 20-plus years of nurturing, the *Observer* has become one of Washington's larger weekly newspapers, with a circulation of about 6,700, and its staff has won numerous statewide awards for excellence. In addition, under his direction, the *Observer* has sponsored the publication of several books concerning the area's history. Winters welcomes visitors, is a good listener, and his door is usually open, even when he is hard at work. (Damian Mulinix photograph.)

Joe Knowles

Peninsula folks still remember artist Joe Knowles as a character of the first order. He made his name as the "Nature Man" by surviving in the Maine woods without clothing, food, or equipment except for a knife. He parlayed his adventure into a vaudeville career and wound up on the Seaview beach living in a shack built of driftwood. He frequently drove his touring car with the top down, his big white dog, Wolf, riding in the front passenger seat and his wife and his young woman art student sitting in the back. His paintings and etchings became collectible. Notably, though, he never received payment for his 12-by-3-foot oil painting *North Beach Peninsula*, which was displayed prominently in the Washington State Exhibit at the 1933 Century of Progress Exposition in Chicago. The city fathers of Long Beach who commissioned it refused, claiming it was incorrectly named. A series of his oil paintings depicting the early years of western North America's settlements hangs in the lobby of the historical Monticello Hotel in Longview, Washington.

Emery Neale

Tennis was Emery Neale's lifelong passion. He began playing as a child, played varsity tennis at Stanford, and, at age 45, played Seniors at Wimbledon. A Seaview "summer kid," he eventually retired there to his parents' home, which had been built of lumber salvaged in 1925 from the wrecked schooner *Coaba*. Neale built the public tennis courts in Seaview as a memorial to his parents.

Martin Gabriel Thorsen

Like many successful Portland entrepreneurs, Martin Gabriel Thorsen, proprietor of the Thorsen Paint Company, chose Charles Beaver's (see page 116) Sea View development as a summer getaway for his family. There, he built a small farm featuring a handsome house with a distinctive glassed-in sunporch. He stocked the farm with animals, particularly horses for the riding pleasure of family and friends.

Noel and Pat Thomas

In 1974, Noel and Pat Thomas left the fast-paced advertising world of New York and Los Angeles (Noel, an art director; Pat, a copy editor) and headed for Seaview, where Noel had spent childhood summers. There, they began building miniature houses for collectors and museums. By their retirement in 2011, they had created 64 structures, including houses, commercial buildings, outbuildings, and roadside stands, all built in conventional dollhouse scale: one inch to one foot. Their trademark aging process gives their buildings a patina of wear and weather, along with subtly detailed evidence of human occupation. In recent years, Noel has returned to his first love, watercolor, and was accepted in 2001 into the prestigious American Watercolor Society. Pat pursues her interest in poetry, and her first book, *The Woman Who Cries Speaks*, was published under her pen name, Patricia Staton, in 2008. (Both, Open House photographs.)

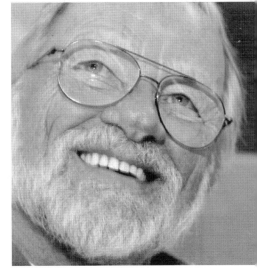

Charles Mulvey

For 60 years Charles Mulvey painted watercolors of familiar Peninsula scenes—boats, barns, houses, and sunsets on the beach. Even while vacationing in Hawaii, he would put on his old straw hat, set up his easel on the sand, and paint the beach at home on the Long Beach Peninsula, much to the confusion of passersby. His studio, the Sea Chest, was a must-see for visitors to the Peninsula, who delighted in a chance to chat with the soft-spoken artist and experience his wry sense of humor. On evenings with particularly fine sunsets over the Pacific, locals often credit Mulvey and his heavenly paintbrush.

BIBLIOGRAPHY

Davis, Charlotte and Edgar. *They Remembered*. 4 vols. Ilwaco, WA: Pacific Printing Co., 1981–1994.

Feagans, Raymond J. *The Railroad that Ran by the Tide*. Berkeley, CA: Howell-North Books, 1972.

Hawthorne, Julian, ed. *History of Washington*. Vols. 1 and 2. New York, NY: American Historical Publishing Company, 1893.

Lloyd, Nancy. *Observing Our Peninsula's Past*. Vols. 1 and 2. Long Beach, WA: The *Chinook Observer*, 2001, 2002.

McDonald, Lucile. *Coast Country: A History of Southwest Washington*. Hillsboro, OR: Binford & Mort, 1966.

Oesting, Marie. *Oysterville Cemetery Sketches*. Self-published, 1988.

Turner, Frank. "From Auld Lang Syne." *Ilwaco Tribune*. 1952–1958.

Williams, L.R. *Chinook by the Sea*. Portland, OR: Kilham Stationery and Printing Company, 1924.

Williams, L.R. *Our Pacific County*. Raymond, WA: *Raymond Herald*, 1930.

Wolf, Edward C. *A Tidewater Place*. Long Beach, WA: The Willapa Alliance, 1993.

INDEX

Aase, Carl, 30
Allison, Guy, 88
Anderson, Laurie, 117
Anderson, Melinda "Sue," 33
Andrew, Bob, 106
Andrews, Bert, 52
Andrews, Minnie, 52
Andrews, Ruby Bilodeau, 45
Bailey, Jayne, 4, 77
Bales, Bob, 30
Bales, Don, 30
Beaver, Charles, 116, 117, 122
Becken, Edward, 20
Begg, William, 83
Bellinger, Steve, 95
Biggs, Kendall, 103
Bilodeau, Pearl Andrews, 45
Bowmer, Angus, 16
Brooks, Anna, 45, 66
Brumbach, William, 20
Buesing, Jim, 105
Buesing, Kay, 105
Bush, Lin, 42, 43
Campiche, David, 117
Campiche, Dr. John, 28, 110
Campiche, Val, 4, 110, 111
Cannon, Gyla Kemmer, 45
Canouse, Mrs., 42, 43
Caulfield, Mary Ellner, 53
Charley, Chief George Allen, 4, 14
Chellis, Ed, 89
Chellis, Walt, 89
Chinook Liberty Wagon, 16
Clair, Harry, Jr., 89
Clark, Isaac Alonzo, 40
Clarke, Heidi Anderson, 33
Colbert, Catherine Petit, 11
Colbert, Frederick, 11
Corder, Loren, 96
Cox, Donald, 103
Crowley, Daniel James, 90
Davis, Charlotte Herrold, 13, 125
Davis, Sarah Brand, 42, 43
Dobbs, Al, 30
Dobney, Mark, 4, 35
Doupé, Joe, 23

Downer, Jack, 94
Downer, Lucille, 94
Driscoll, Dan, 58
Elliott, Dorothy, 74
Embree, Frank, 20
English, David, 42, 43
Espy, Edwin, 54
Espy, Harry Albert "H.A.," 41
Espy, Helen, 45
Espy, Kate Hulbert Wichser Miller, 44, 45
Espy, Muriel "Mona," 45
Espy, Robert Hamilton "R.H.," 40, 41, 44
Espy, Willard, 4, 54, 63
Etchison, Birdie, 92
Fisher, Laura, 45
Fisher, Myra, 45
Fitzpatrick, Charles, 85
Friedlander, Polly, 63
Gaither, George, 20
Gifford, Woodrow J., 118, 119
Gile, Albion, 17
Gillespie, Effie, 42, 43
Gillespie, Ola, 42, 43
Goulter, Allen, 112
Goulter, Edwin R. "Bud," 59
Goulter, Elaine, 112
Grable, Jack, 20
Graham, Perry, 20
Gray, Steve, 30
Gustafson, Roy, 111
Hager, Ambrose, 99
Hall, Claude, 20
Hall, Otto, 20
Hall, William, 20
Hanner, Alan Housel "Pete," 78, 79
Harding, Cherry, 35
Hayward, Cyndy, 85
Heckes, Edna May, 53
Heckes, Helen Thompson, 4, 45, 60
Heckes, Pete, 61
Herrold, Roy Hudson, 12, 20
Hicklin, Ada Brown, 42, 43
Hicklin, John, 42, 43
Hill, Otto, 97

Holm, Alice, 45
Holway, Susan, 4, 58
Holway, Theodore "Ted," 56, 58
Howerton, J.A., 20, 24
Hutton, Clarence, 20
Hutton, Mollie, 42, 43
Ilwaco basketball team, 1905–1906, 21
Ilwaco High School champions, 1959, 30
Ilwaco Silver Cornet Band, 20
Ilwaco soccer team, 1903, 20
Jackson, Professor, 20
Jacobe, Bill, 30
Jake-the-Alligator-Man, 115
Jensen, Luke, 4, 38
Johnson, Cecelia "Jane" Haguet, 46, 47
Kary, Randall, 36
Kary, Tony, 36
Kemmer, Ann Isabel, 53
Kemmer, Jim, 4, 61
Ketel, Catherine, 112
Ketel, Ed, 112
Kincaid, Louise, 56
Kincaid, Trevor, 8, 56, 75
King, Alfred E., 22
Knowles, Joe, 8, 121
Knutzen, Doug, 95
Kofoed, Claude, 20
Kofoed, George, 20
Kola, John, 25
Kola, John, Jr., 25
Kola, Mrs. John, 25
Kola, Otto, 25
Kola, Tyne, 25
Lee, Don, 30
Leech, Wesley "Geno," 37
Lehman, Emma, 45
Lilly, May, 42, 43
Lindburg, Alfretta Eva, 53
Little, Bill, 55
Little, Dale Espy, 44, 45, 55
Lloyd, Nancy, 34, 125
Loomis, Lewis Alfred, 7, 48, 49
Lucas, Jimella, 76
Mack, Andrea, 78

Mack, Art, 89
Mack, Christl, 78
Mack, Günter, 78
Mack, Wolfgang, 78
Main, Nanci, 76
Maki, Gerri, 96
Mandel, Mary Lou, 107
Marchand, Al, 31
Marchand, Jessie, 31
Marden, Frank, 20
Marden, Fred, 20
Markham, Amon, 20
Markham, Daniel, 20
Markham, Joseph, 20
Marsh, Wellington, W., 114
Matthews, Art, 89
Matthews, Rebecca Brown, 42, 43
Matthews, Steven Adelbert "S.A.," 4, 86, 87, 88
Matthews, William, 42, 43
McGowan, Henry, 15
McGowan, Patrick, 15
McNabb, Henry J., 20
McPhail, Ardell, 33
McPhail, Malcolm, 33
Meyers, Guy C. 91
Millner, Ray, 100
Morehead, John "J.A.," 65
Morehead, Johnny, 89
Morris, Lolita Tinker, 99
Mulvey, Charles, 124
Murakami, Ira, 70
Murakami, Jeff, 70
Murfin, Dick, 26
Murfin, Martha Turner, 4, 26, 27
Neace, Dr. Lewis, 28
Neale, Emery, 122
Nelson, Charles A., 66
Nelson, Irene, 45
Nitzel, Jean Tilden, 104
O'Connell, Red, 106
Ocean Park Theatrical Group, 89
Oller, Verna Smith, 80
Olson, Edith, 45
Oman, Dennis, 30
Osborne, Al, 20
Oysterville Sewing Circle, 1918, 45
Oysterville soccer team, 1880s, 50
Oysterville Women's Club, 1932, 45
Parks, Dr., 20
Paxton, Betty, 4, 102

Peterson, James "Jim," 30, 32
Petit, Amelia Aubichon "Grandmère," 10, 13
Phelps, Lorrie Knudson, 113
Poulshock, Barbara Baker, 4, 93
Prest, Amanda, 17
Prest, Jasper, 17
Prest, Johnny, 17
Prest, Lisa, 17
Prest, Rita, 17
Redell, Barbara "Bitty," 96
Rice, Louise, 86
Richardson, Beulah, 45
Robinson, Noreen, 34
Russell, Margaret, 74
Samples, Everett "Spider," 20
Sankela, Jenny, 24
Sargant, Alice, 45
Sargant, Maggie, 45
Saunders, Sharon, 2, 4
Sayce, Bonnie, 73
Sayce, Clyde, 73
Sayce, Kathleen, 72
Schenk, Dan, 36
Schenk, Eli, 36,
Schenk, James, 36
Schenk, Justice, 36
Schenk, Pat, Jr., 36
Schenk, Pat, Sr., 36
Schenk, Ryan, 36
Schoewe, Gordon, 6, 111
Schwartz, Keleigh, 104
Seaborg, Astor, 20
Sheldon, Dick, 71
Shier, Charles, 30
Simmons, Nels, 20
Slagle, Sanford, 89
Snyder, Karen, 108
Snyder, Sen. Sid, 109
Sparrow, Emma Bailey, 42, 43
Stevens, Beverly, 89
Stevens, Nyel, 64
Stone, Ray, 75
Stoner, Ina, 45
Sugarman, Ken, 30
Suldon, William, 20
Summerfelt, Bill, 89
Suomela, Arnie, 32
Suomela, Rhea, 32
Tanger, Ella, 42, 43
Tartar, Vance, 57

Taylor, Adelaide Stuart, 84
Taylor, Mrs., 45
Taylor, Dorothy, 96
Taylor, Sarah Anderson, 33
Teachers' Institute, 1885, 42, 43
Tetz, Gary, 30
Thomas, Noel, 4, 123
Thomas, Pat, 123
Thorsen, Martin Gabriel, 122
Timmen, Jesse, 20
Tinker, Henry Harrison, 98
Troeh, Catherine Herrold, 13
Turner, Frank, 26, 125
Turner, Joseph H., 43
Turner, Martha Brownfield, 43
Wachsmuth, Chester "Tucker," 6, 50
Wachsmuth, Danielle, 50
Wachsmuth, Louis, 50
Wachsmuth, Louise, 45
Wachsmuth, Meinert, 51
Watterberg, Russell, 92
Welsh, Charles "Carlos," 63
Welsh, Sharon Montoya, 63
Whealdon, Isaac, 18, 29
Whealdon, Mary Ann, 18, 29
Wiegardt, Gustave A. Jr. "Dobby," 6, 68, 69
Wiegardt, Eric, 67–69
Wiegardt, Heinrich, 67
Wiegardt, Laurine, 67
Williams, John G., Jr., 29
Williams, Julia Hoare, 116
Williams, L.D., 19
Wilson, Dora Espy, 45
Wilson, Les, 71
Winters, Matt, 120
Wirt, Mary, 45
Wise, Ben, 20
Wolfe, Frank, 72
Wood, Elizabeth Lambert, 101
Woodcock, Myrtle Johnson, 47
World War I buglers, 21
Worthington, Lynn, 30
Wright, T.J. "Shorty," 62
Yeager, Edgar, 89
Yeager, Owen, 89

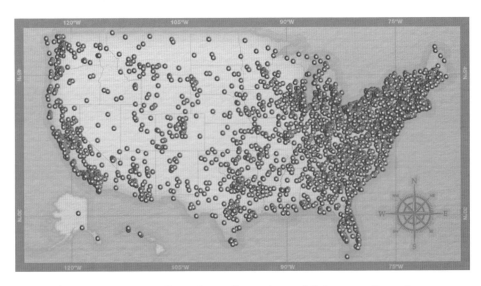